AMERICAN G⊕DS:
THE OFFICIAL COLORING BOOK

NEIL GAIMAN

wm

WILLIAM MORROW
An Imprint of HarperCollins*Publishers*

HarperCollins books may be purchased for educational, business, or sales promotional use. For information, please email the Special Markets Department at SPsales@harpercollins.com.

The text in this work originally appeared in *American Gods* by Neil Gaiman, published by William Morrow, an imprint of HarperCollins Publishers.

FIRST EDITION

Designed by Diahann Sturge

Library of Congress Cataloging-in-Publication Data has been applied for.

ISBN 978-0-06-268871-2

17 18 19 20 21 BRR 10 9 8 7 6 5 4 3 2

AMERICAN GODS:
THE OFFICIAL COLORING BOOK

"This is the only country in the world,"

said Wednesday, into the stillness,

"that worries about what it is."

The best thing—in Shadow's opinion, perhaps the only good thing—about being in prison was a feeling of relief. The feeling that he'd plunged as low as he could plunge and that he'd hit bottom. He didn't worry that the man was going to get him, because the man had got him. He did not awake in prison with a feeling of dread; he was no longer scared of what tomorrow would bring, because yesterday had brought it.

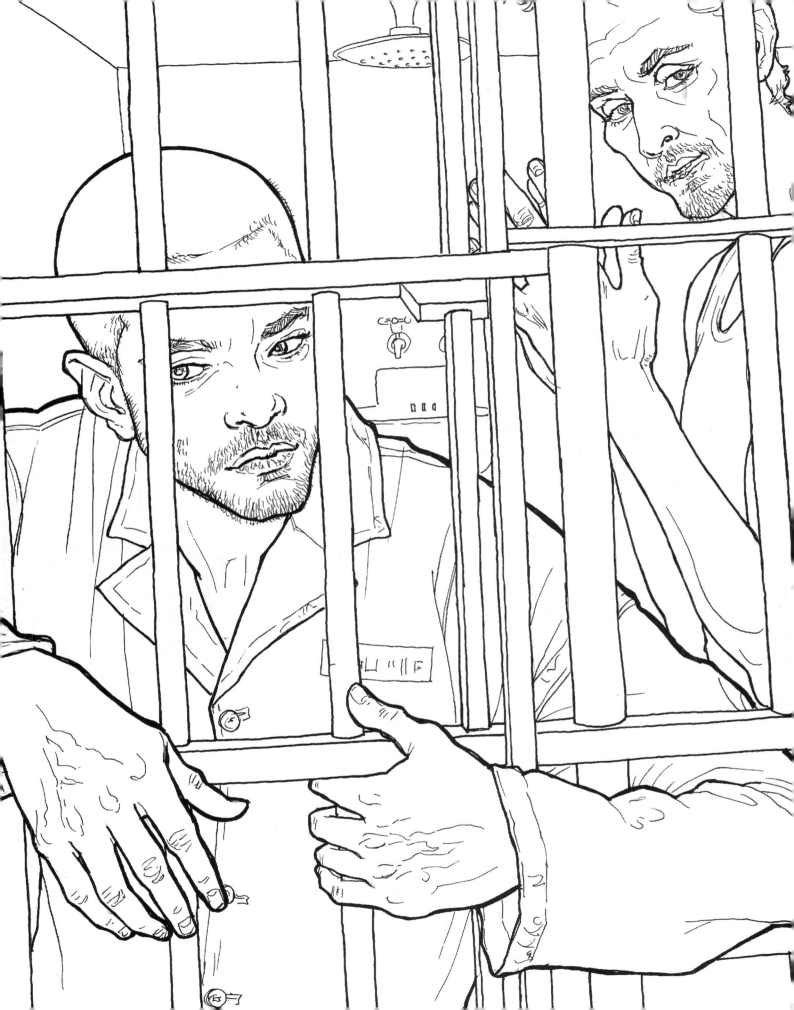

Then the warden said, "It's like one of them good-news, bad-news jokes, isn't it? Good news, we're letting you out early, bad news, your wife is dead." He laughed, as if it were genuinely funny.

Shadow said nothing at all.

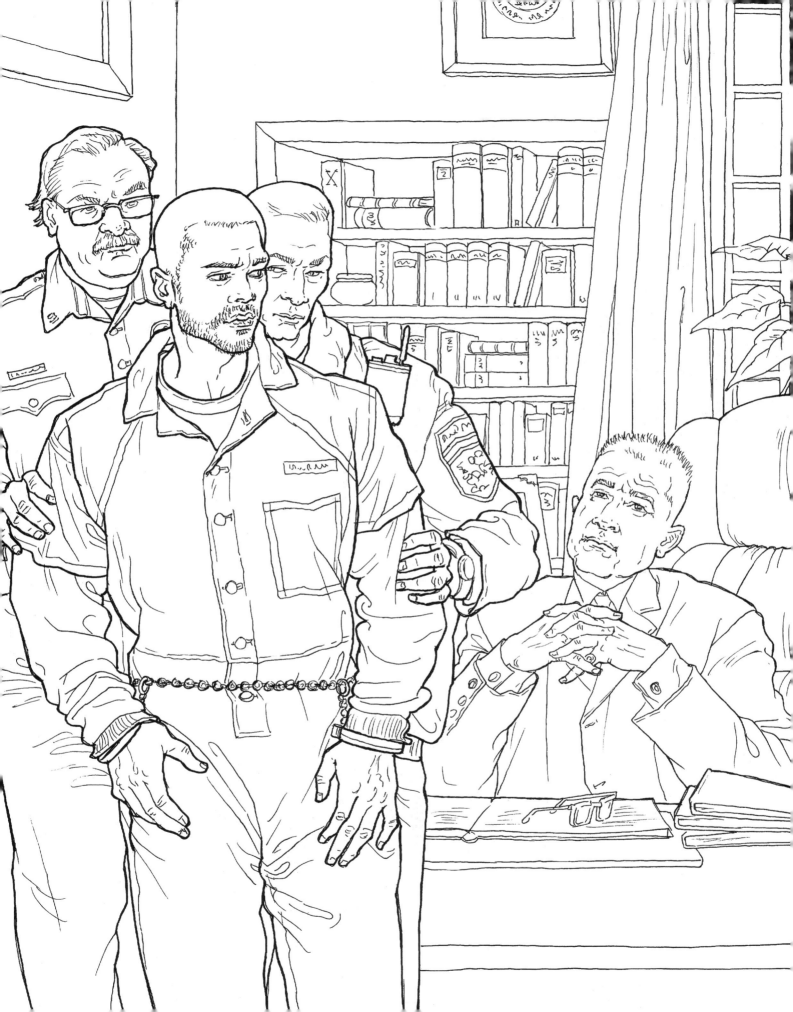

"Bring me your lust in the morning, and bring me relief and your blessing in the evening. Let me walk in the dark places unharmed and let me come to you once more and sleep beside you and make love with you again. . . . Your eyes are stars, burning in the firmament, and your lips are gentle waves that lick the sand, and I worship them."

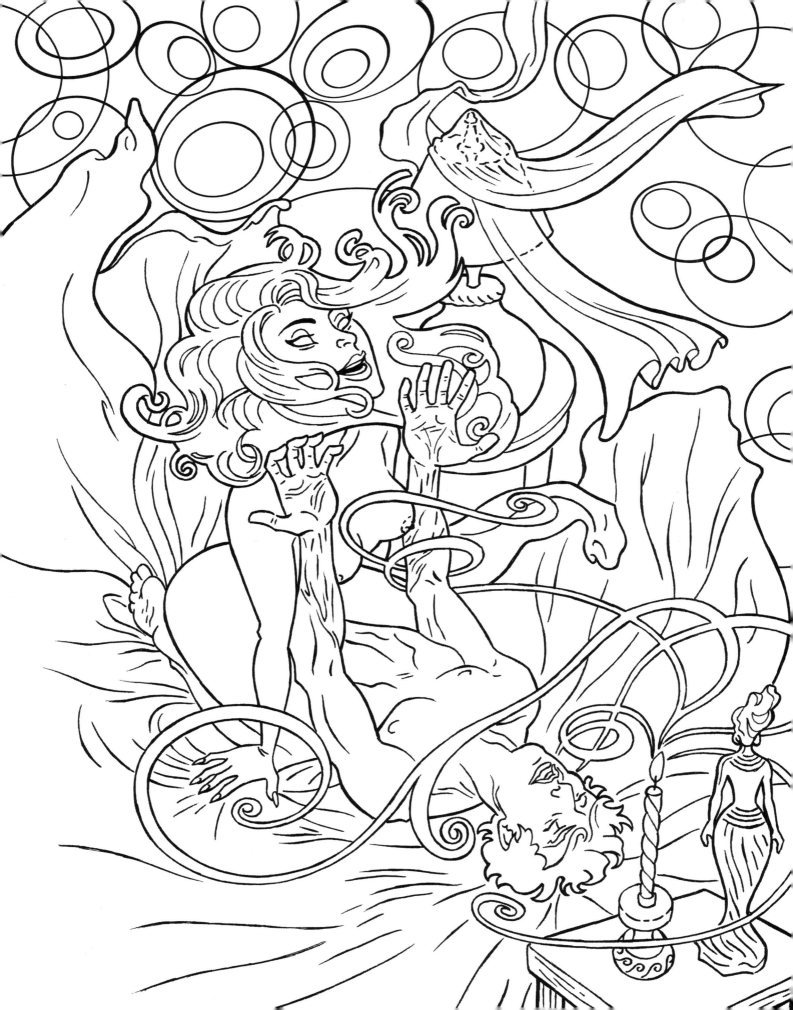

"I don't like you, Mister Wednesday, or whatever your real name may be. We are not friends. I don't know how you got off that plane without me seeing you, or how you trailed me here. But I'm impressed. You have class. And I'm at a loose end right now. You should know that when we're done, I'll be gone. And if you piss me off, I'll be gone too. Until then, I'll work for you."

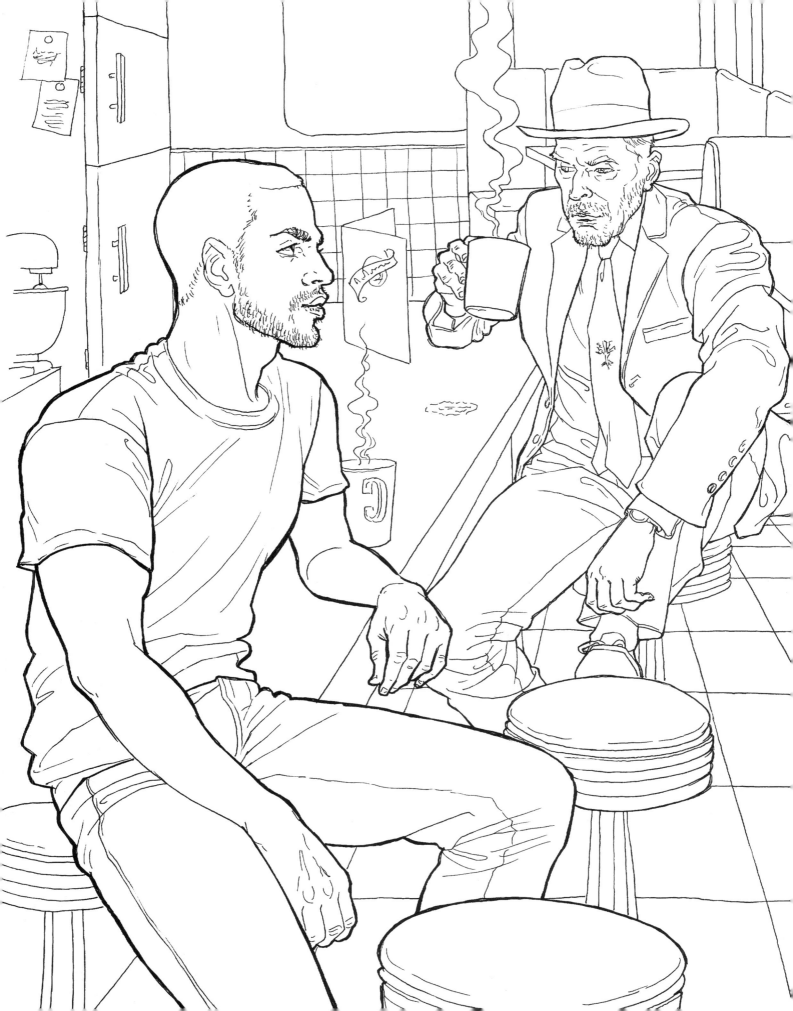

He wondered what Laura would say when she saw him, and then he remembered that Laura wouldn't say anything ever again and he saw his face, in the mirror, tremble, but only for a moment.

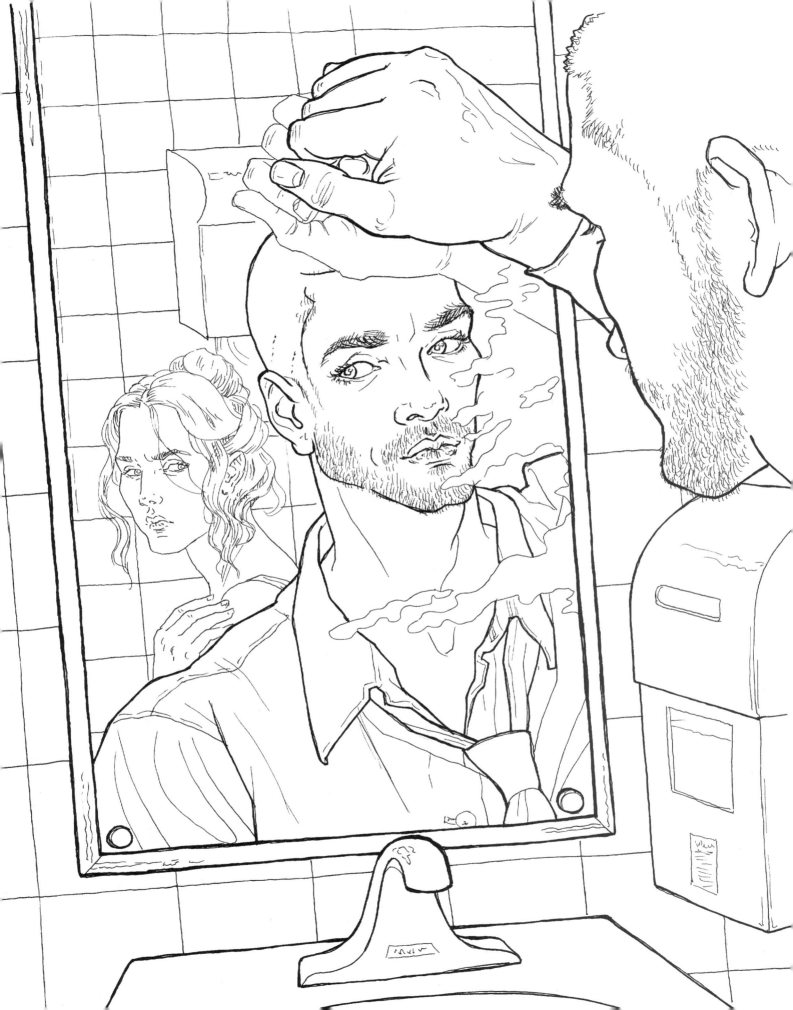

Laura lay with her eyes closed, and her arms folded across her chest. She wore a conservative blue suit he did not recognize. Her long brown hair was out of her eyes. It was his Laura and it was not: her repose, he realized, was what was unnatural. Laura was always such a restless sleeper.

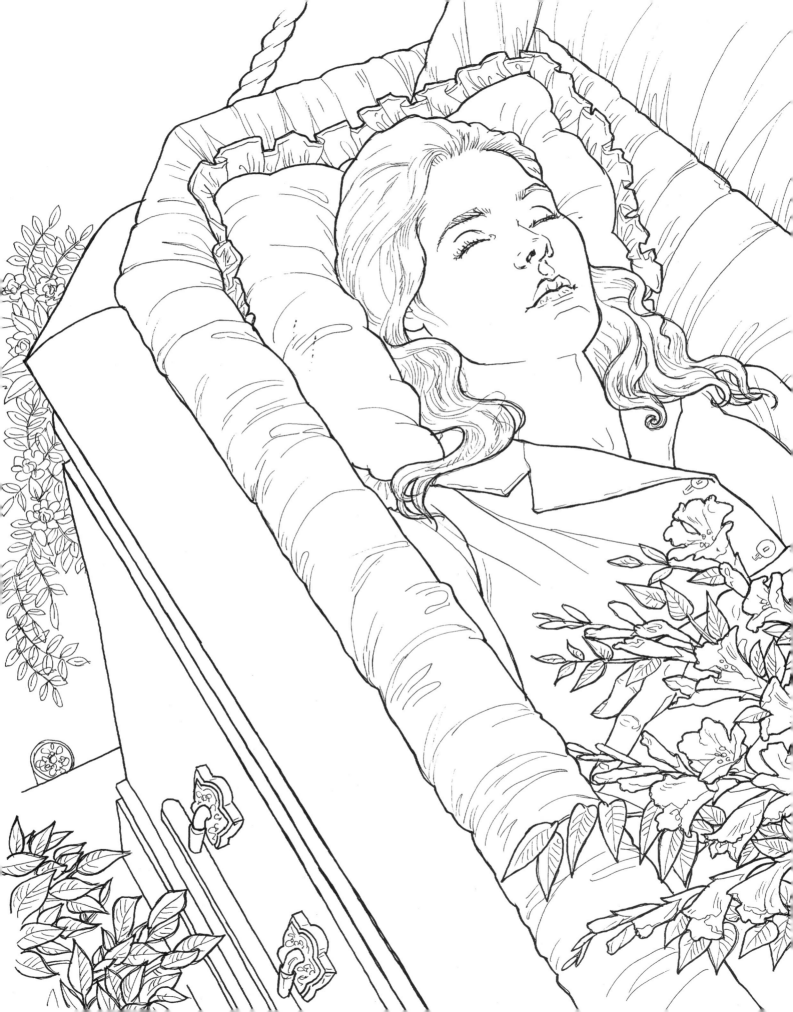

A precise voice, fussy and exact, was speaking to him, in his dream, but he could see no one.

"These are gods who have been forgotten, and now might be dead. They can be found only in dry histories. They are gone, all gone, but their names and their images remain with us."

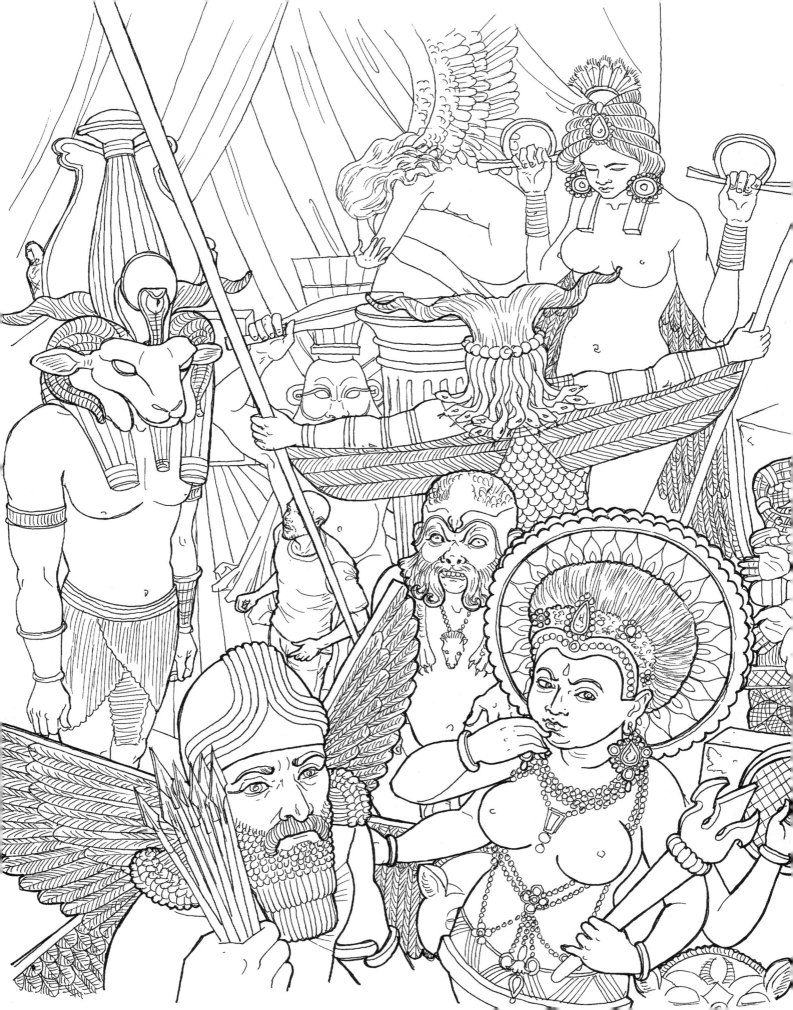

It was more than a hundred years before Leif the Fortunate, son of Erik the Red, rediscovered that land, which he would call Vineland. His gods were already waiting for him when we arrived: Tyr, one-handed, and gray Odin gallows-god, and Thor of the thunders.

They were here.

They were waiting.

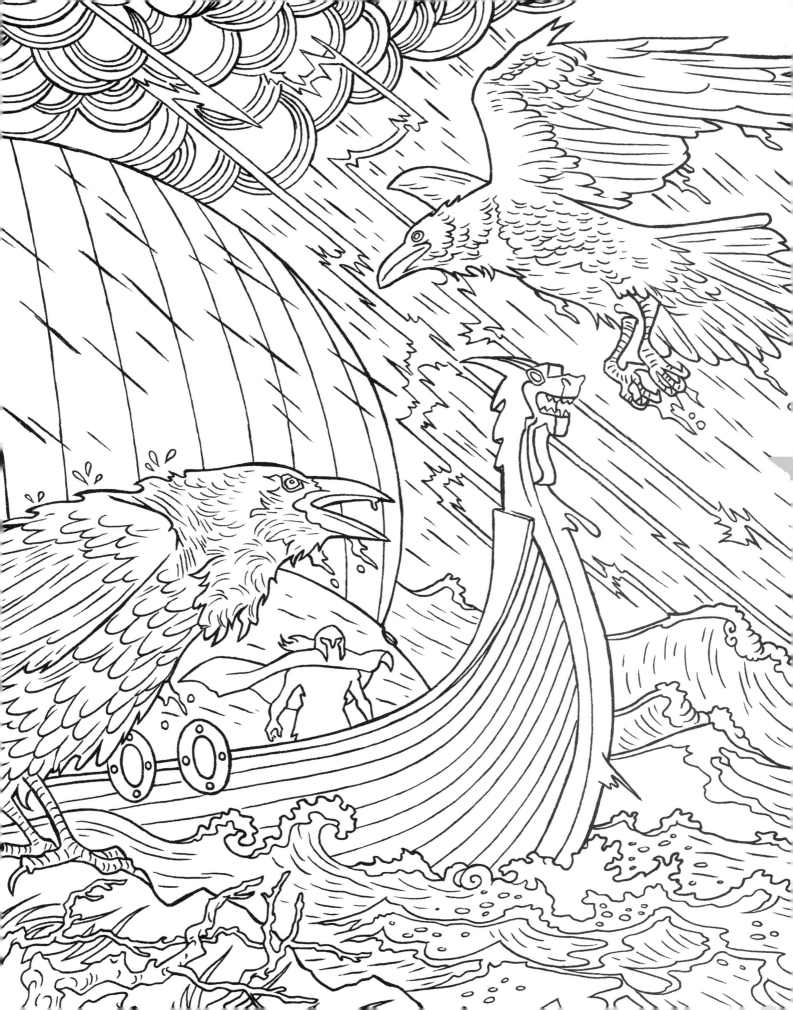

"Are they gypsies?" asked Shadow.

"Zorya and her family? Not at all. They're not *Rom*. They're Russian. Slavs, I believe."

"But she does fortune-telling."

"Lots of people do fortune-telling. I dabble in it myself."

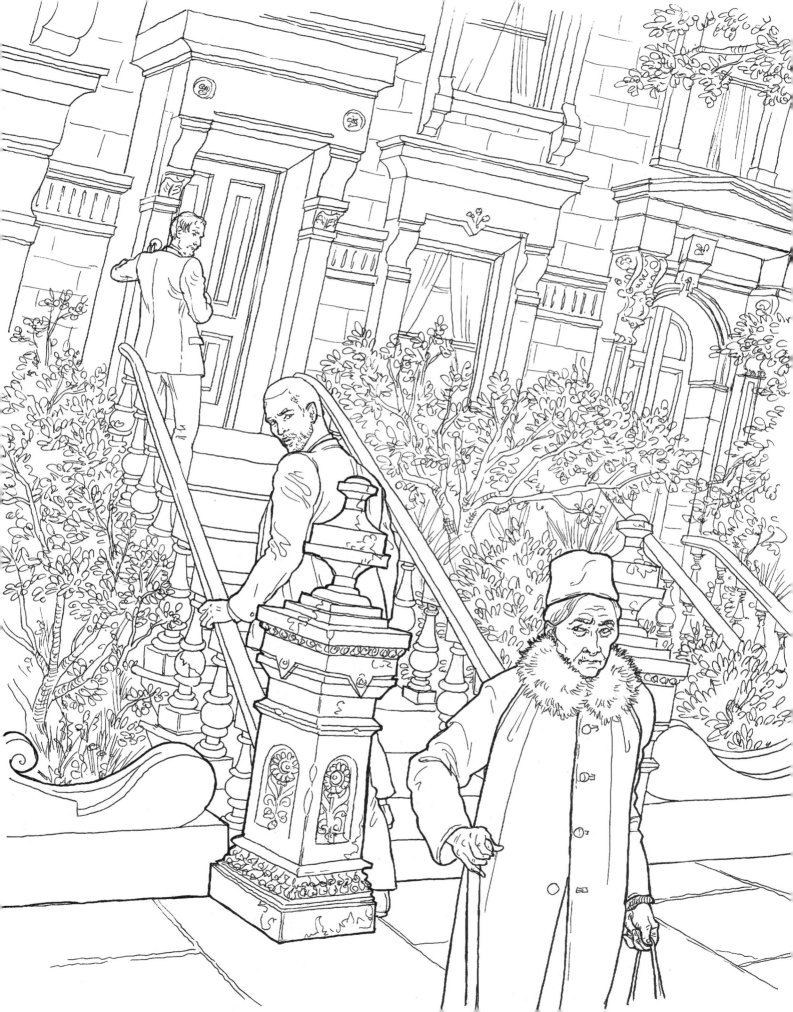

Czernobog raised a craggy eyebrow. "Your master wants me to come with him. To help him with this nonsense. I would rather die."

"You want to make a bet. Okay. If I win, you come with us."

The old man pursed his lips. "Perhaps," he said. "But only if you take my forfeit, when you lose."

"And what is that?"

There was no change in Czernobog's expression. "If I win, I get to knock your brains out. With the sledgehammer. First you go down on your knees. Then I hit you a blow with it, so you don't get up again." Shadow looked at the man's old face, trying to read him. He was not joking, Shadow was certain of that: there was a hunger there for something, for pain, or death or retribution.

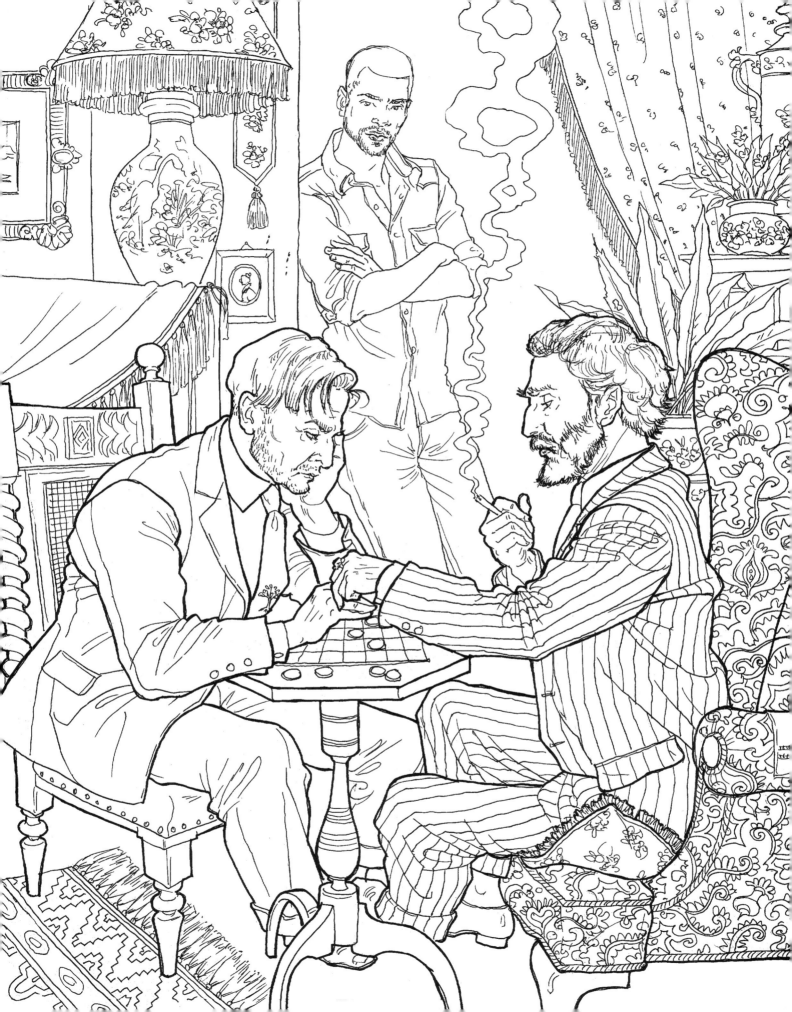

I must be dreaming, thought Shadow, alone in the darkness. *I think I just died.*

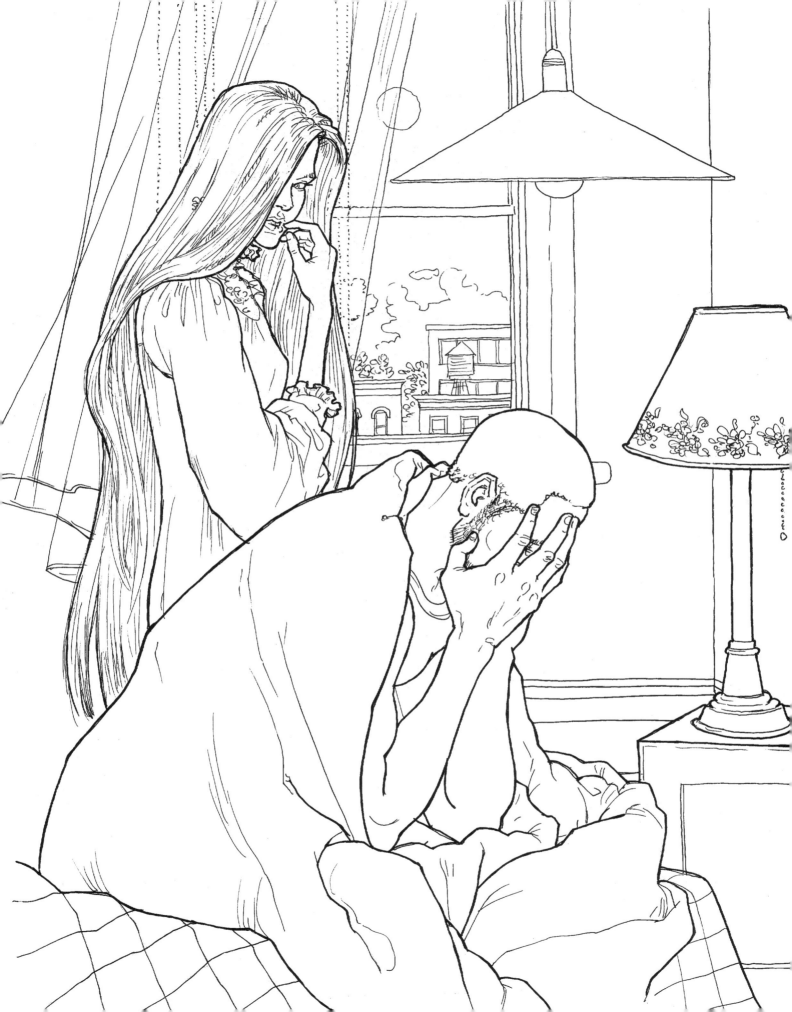

"I feel," Shadow told her, "like I'm in a world with its own sense of logic. Its own rules. Like when you're in a dream, and you know there are rules you mustn't break, but you don't know what they are or what they mean. I have no idea what we're talking about, or what happened today, or pretty much anything since I got out of jail. I'm just going along with it, you know?"

"I know," she said. "You were given protection once, but you lost it already. You gave it away. You had the sun in your hand. And that is life itself. All I can give you is much weaker protection. The daughter, not the father. But all helps. Yes?"

"Do I have to fight you? Or play checkers?" he asked.

"You do not even have to kiss me," she told him. "Just take the moon."

"How?"

"Take the moon."

"I don't understand."

"Watch," said Zorya Polunochnaya.

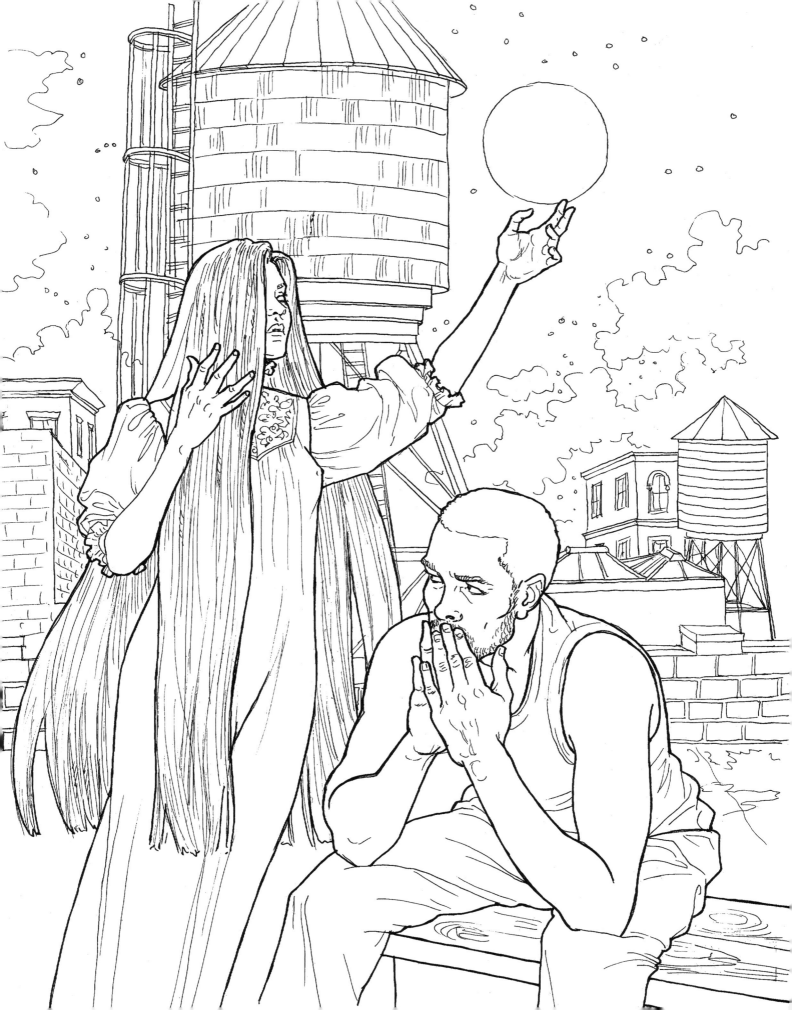

The important thing to understand about American history, *wrote Mr. Ibis, in his leather-bound journal,* is that it is fictional, a charcoal-sketched simplicity for the children, or the easily bored. For the most part it is uninspected, unimagined, unthought, a representation of the thing, and not the thing itself. It is a fine fiction, *he continued, pausing for a moment to dip his pen in the inkwell and collect his thoughts,* that America was founded by pilgrims, seeking the freedom to believe as they wished, that they came to the Americas, spread and bred and filled the empty land.

In truth, the American colonies were as much a dumping ground as an escape, a forgetting place.

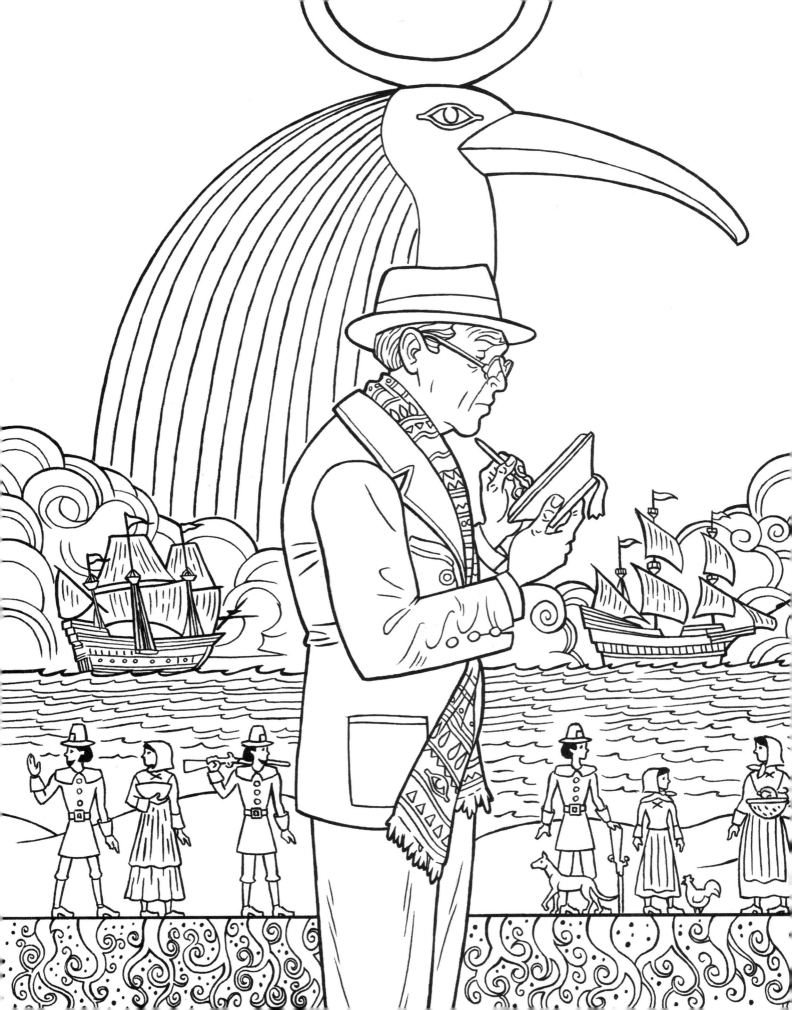

"Lady Liberty," said Wednesday. "Like so many of the gods that Americans hold dear, a foreigner. In this case, a Frenchwoman, although, in deference to American sensibilities, the French covered up her magnificent bosom on that statue they presented to New York."

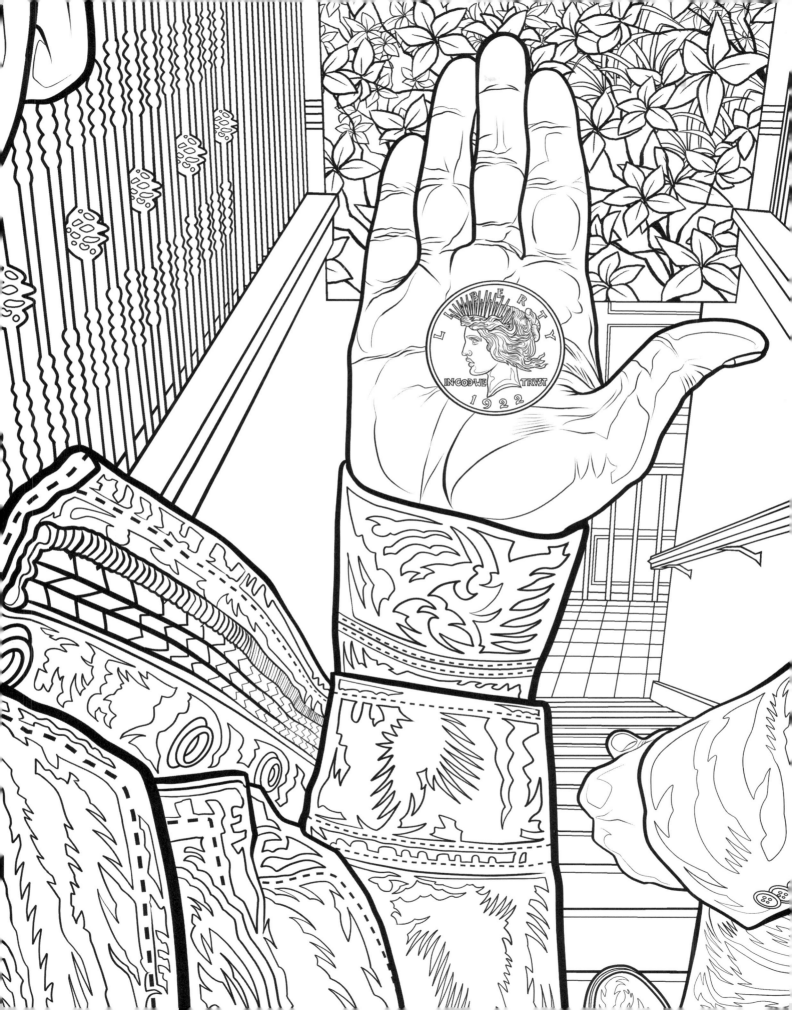

"Well, I don't get anywhere near as much fruit as I used to," said Mr. Nancy, his eyes shining. "But there still ain't nothing out there in the world for my money that can beat a big old high-titty woman. Some folk you talk to, they say it's the booty you got to inspect at first, but I'm here to tell you that it's the titties that still crank my engine on a cold morning." Nancy began to laugh, a wheezing, rattling, good-natured laugh, and Shadow found himself liking the old man despite himself.

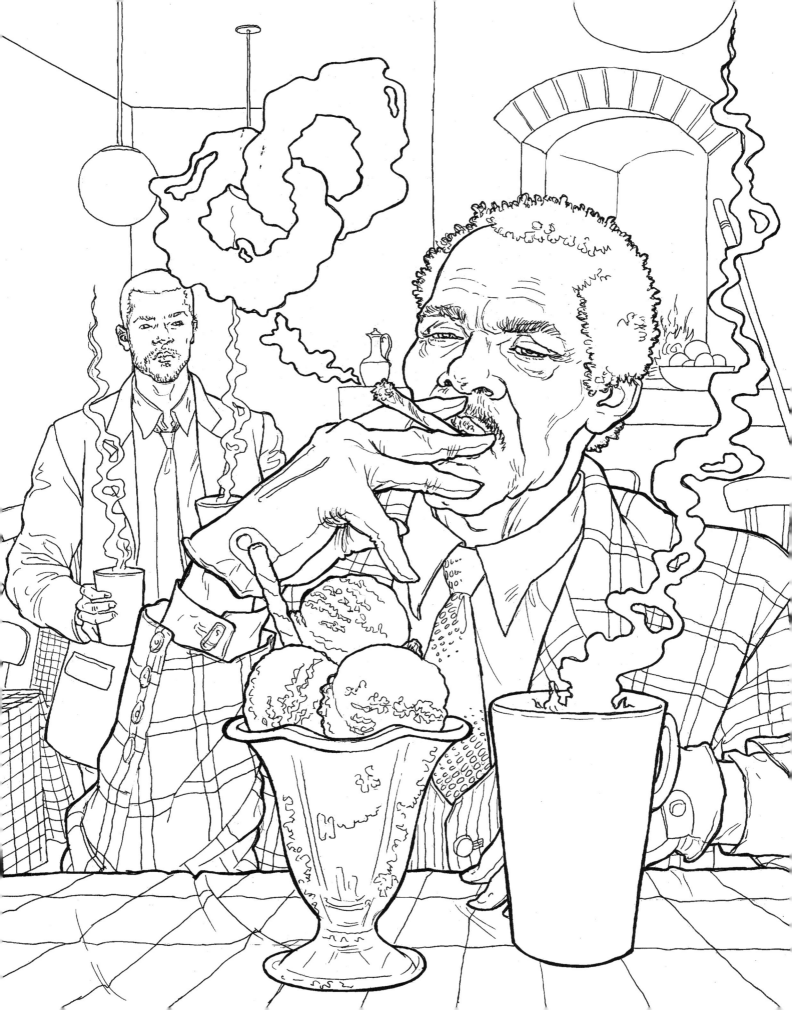

Snow, thought Shadow, in the passenger seat, sipping his hot chocolate. *Huge, dizzying, clumps and clusters of snow falling through the air, patches of white against an iron-gray sky, snow that touches your tongue with cold and winter, that kisses your face with its hesitant touch before freezing you to death. Twelve cotton-candy inches of snow, creating a fairy-tale world, making everything unrecognizably beautiful . . .*

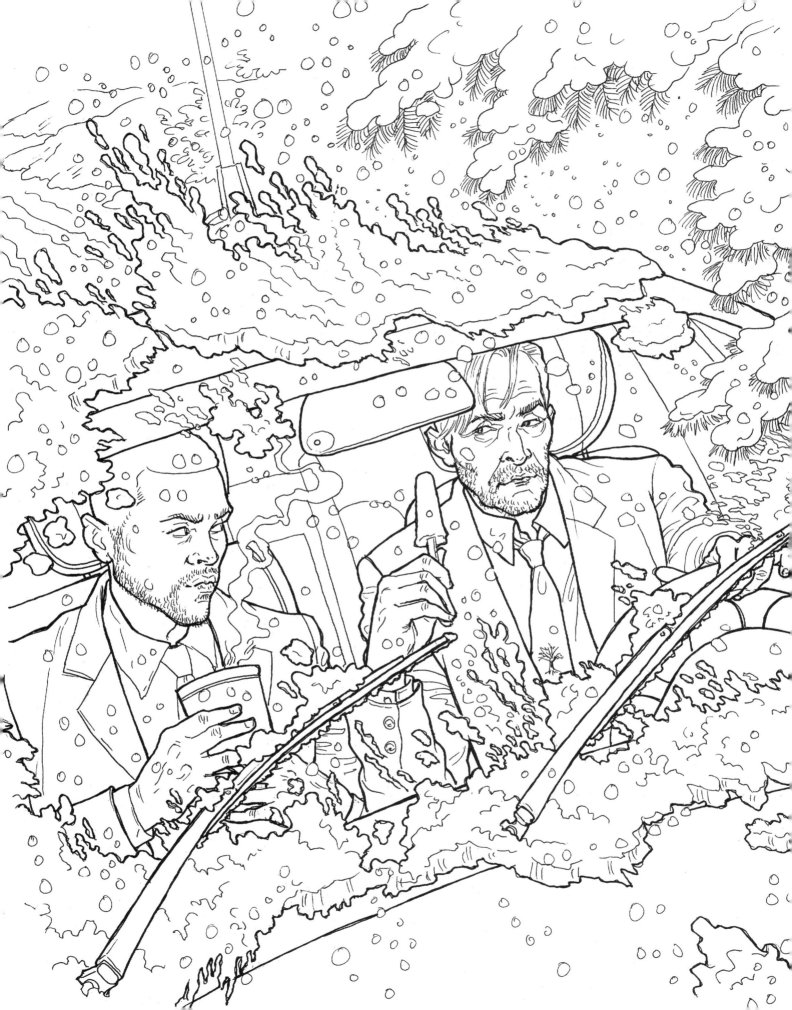

Wednesday was smiling, and Nancy was laughing delightedly, an old man's cackle, and even the dour Czernobog seemed to be enjoying himself. Shadow felt as if a weight were suddenly lifted from his back: three old men were enjoying themselves, riding the world's biggest carousel. So what if they did all get thrown out of the place? Wasn't it worth it, worth anything, to say that you had ridden on the World's Largest Carousel? Wasn't it worth it to have traveled on one of those glorious monsters?

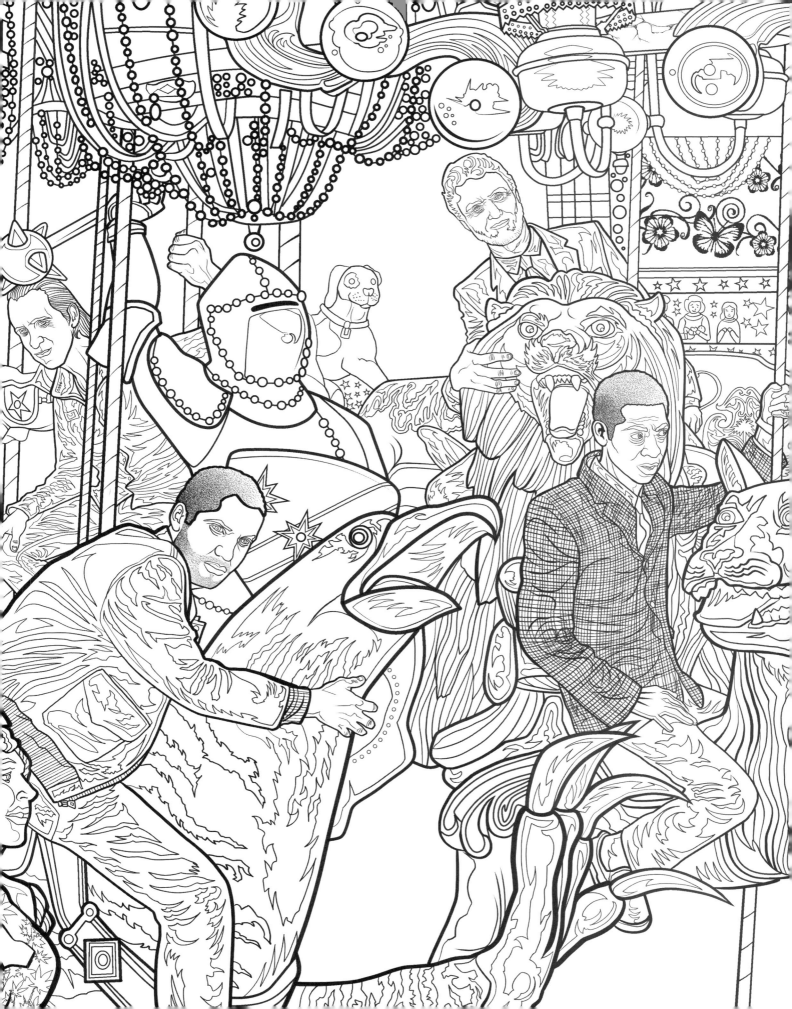

"When the people came to America they brought us with them. They brought me, and Loki and Thor, Anansi and the Lion-God, Leprechauns and Cluracans and Banshees, Kubera and Frau Holle and Ashtaroth, and they brought you. We rode here in their minds, and we took root. We traveled with the settlers to the new lands across the ocean.

"The land is vast. Soon enough, our people abandoned us, remembered us only as creatures of the old land, as things that had not come with them to the new. Our true believers passed on, or stopped believing, and we were left, lost and scared and dispossessed, to get by on what little smidgens of worship or belief we could find. And to get by as best we could."

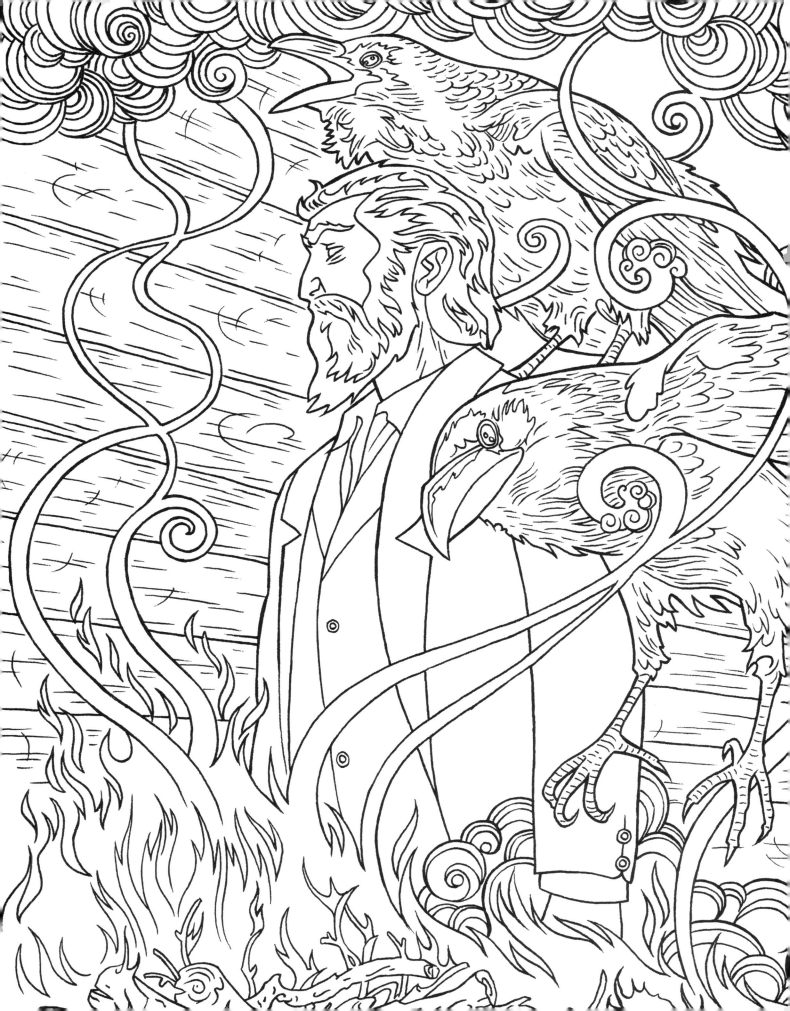

"I want to be alive again," she said. "Not in this half-life. I want to be *really* alive. I want to feel my heart pumping in my chest again. I want to feel blood moving through me—hot, and salty, and real. It's weird, you don't think you can feel it, the blood, but believe me, when it stops flowing, you'll know."

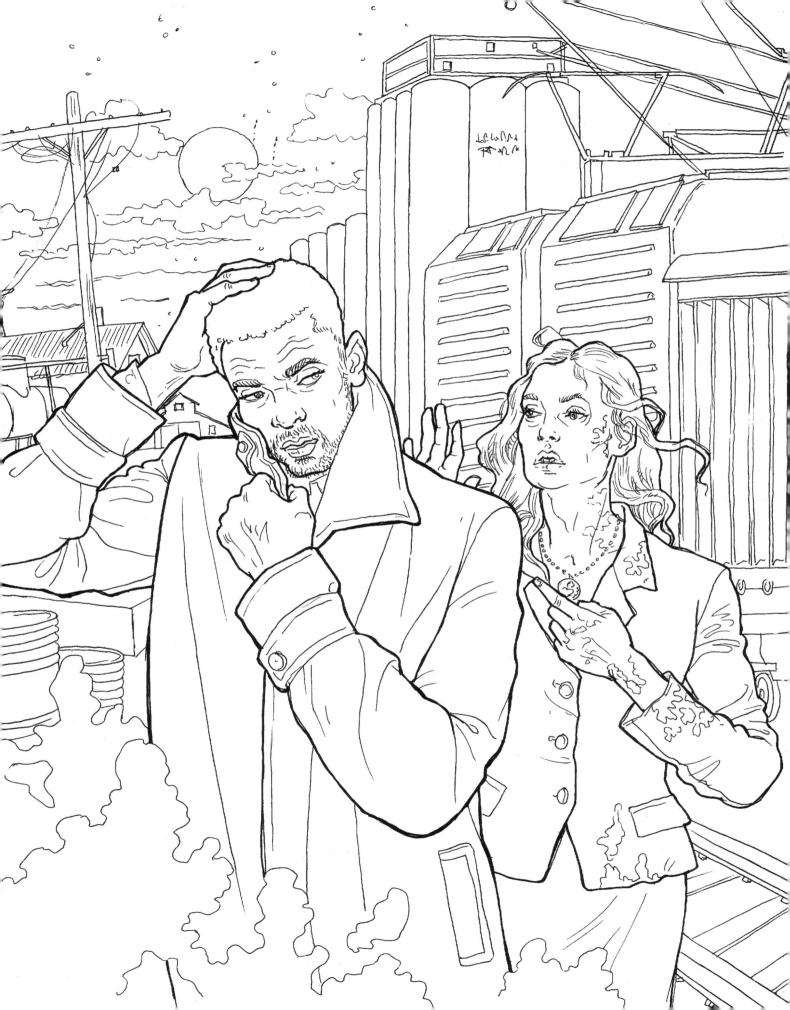

"The storm is coming."

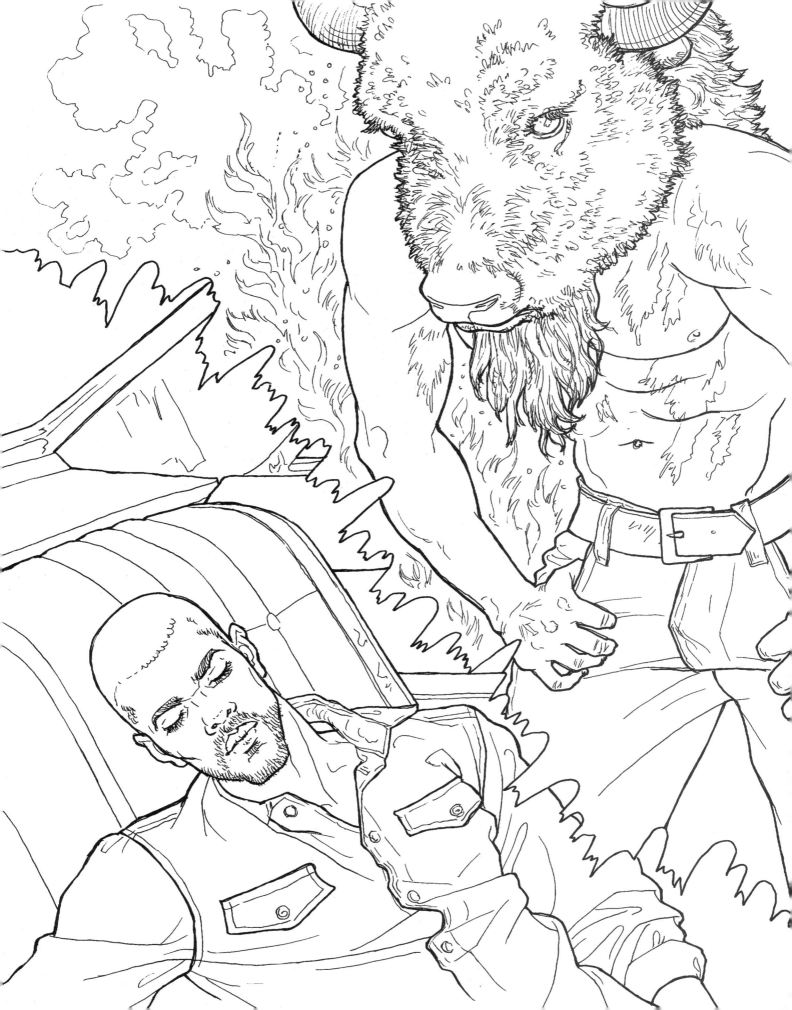

New York scares Salim, and so he clutches his sample case protectively with both hands, holding it to his chest. He is scared of black people, the way they stare at him, and he is scared of the Jews, the ones dressed all in black with hats and beards and side curls he can identify and how many others that he cannot; he is scared of the sheer quantity of the people, all shapes and sizes of people, as they spill from their high, high, filthy buildings onto the sidewalks. . . . He feels strangely light-headed. . . . New York is very simple: the avenues run north to south, the streets run west to east. How hard can it be? he asks himself.

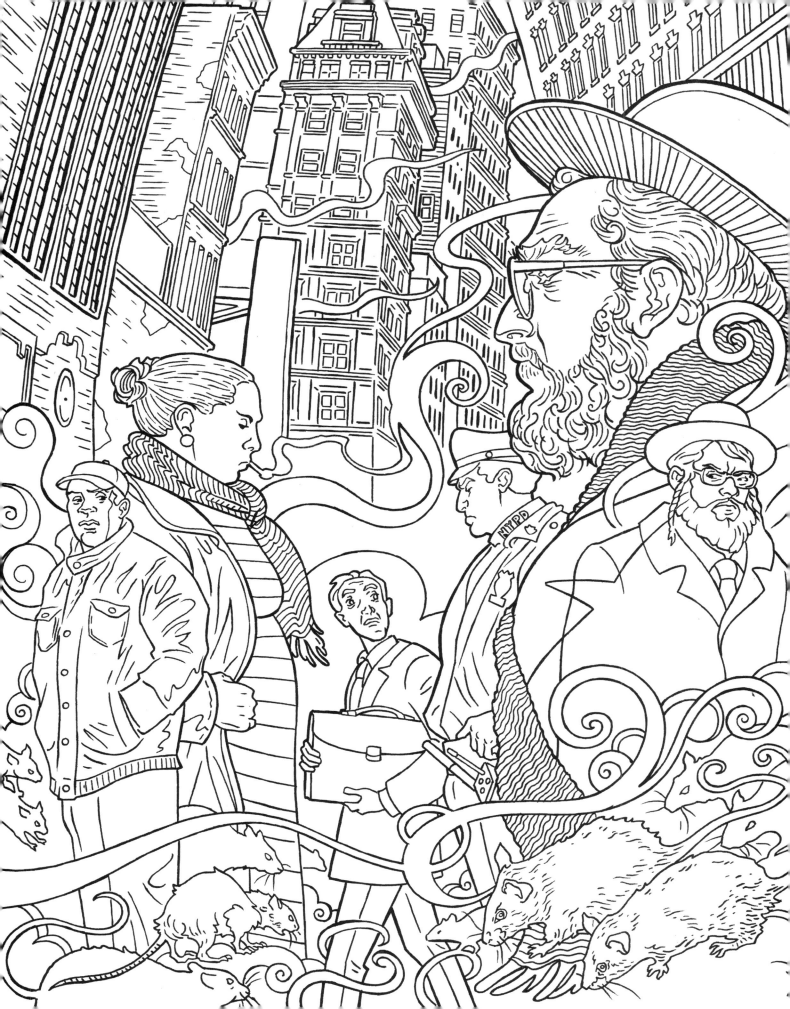

"The Greyhound will be coming through town in twenty minutes. It stops at the gas station. Here's your ticket." He pulled out a folded bus ticket, passed it across the table. Shadow picked it up and looked at it.

"Who's Mike Ainsel?" he asked. That was the name on the ticket.

"You are. Happy Christmas."

"And where's Lakeside?"

"Your happy home for the months to come."

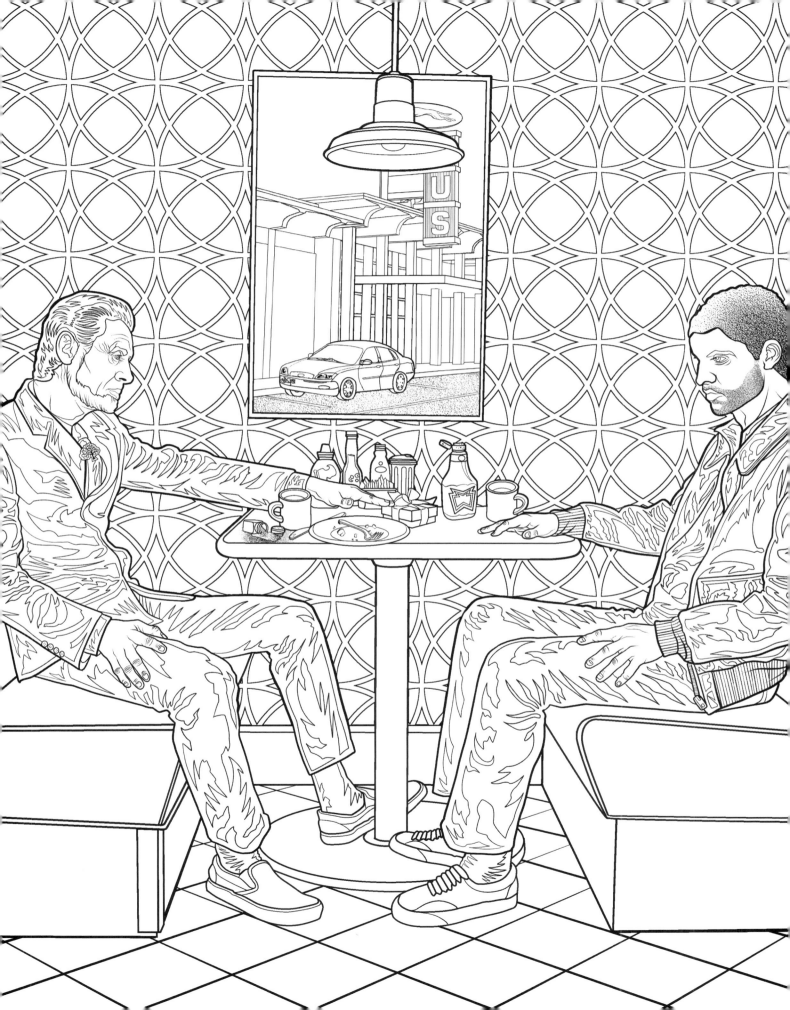

"Are you . . ." Shadow hesitated, and then he asked, "Are you a god too?"

The buffalo man reached one hand into the flames of the fire and he pulled out a burning brand. He held the brand in the middle. Blue and yellow flames licked his red hand, but they did not burn.

"This is not a good place for gods."

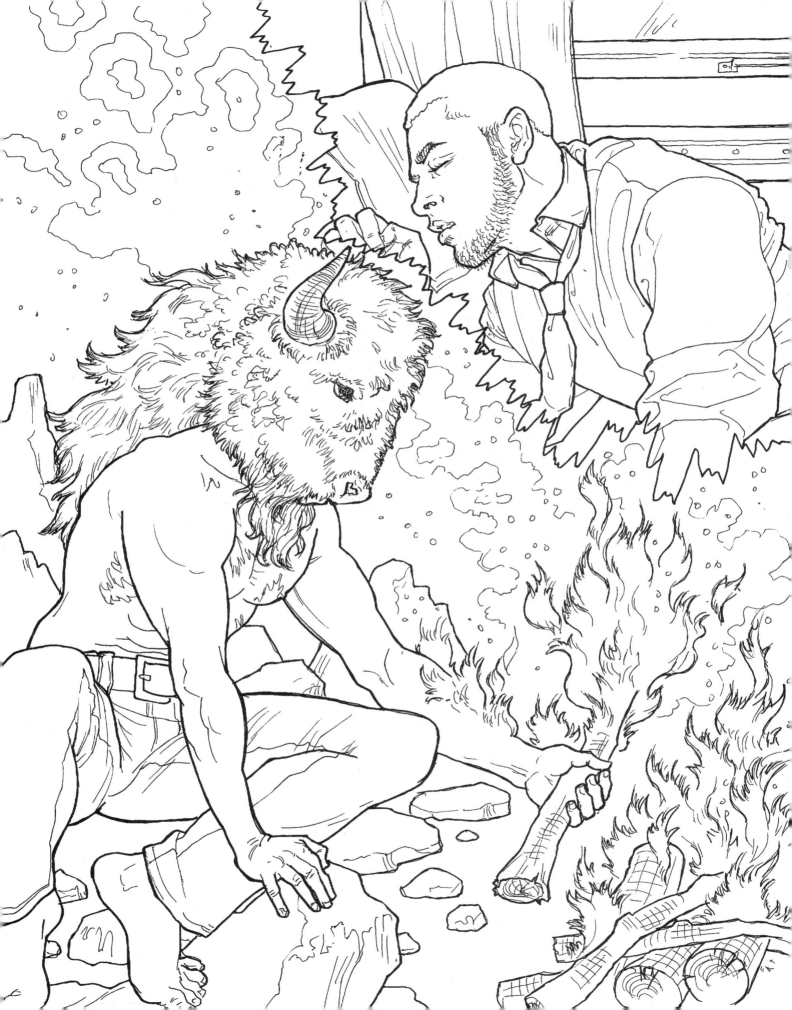

"What I say is, a town isn't a town without a bookstore. It may call itself a town, but unless it's got a bookstore, it knows it's not foolin' a soul."

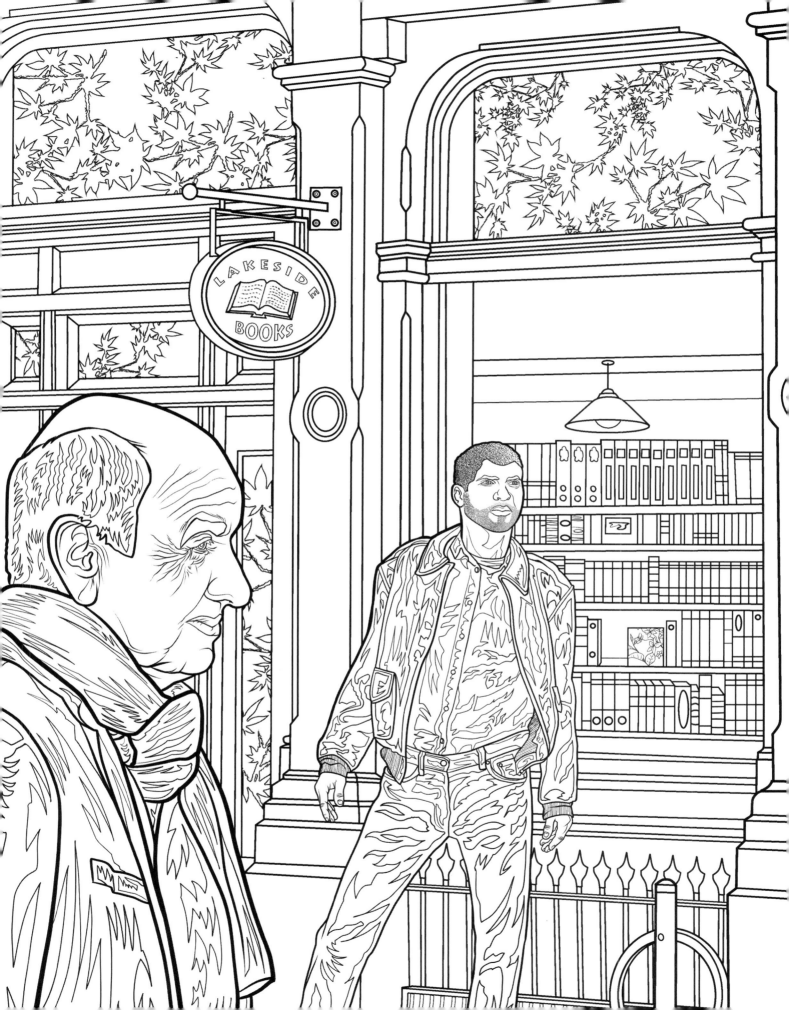

"Biggest problem in this part of the world is poverty. Not the poverty we had in the Depression but something more in . . . what's the word, means it creeps in at the edges, like cock-a-roaches?"

"Insidious?"

"Yeah. Insidious. Logging's dead. Mining's dead. Tourists don't drive further north than the Dells, 'cept for a handful of hunters and some kids going to camp on the lakes—and they aren't spending their money in the towns."

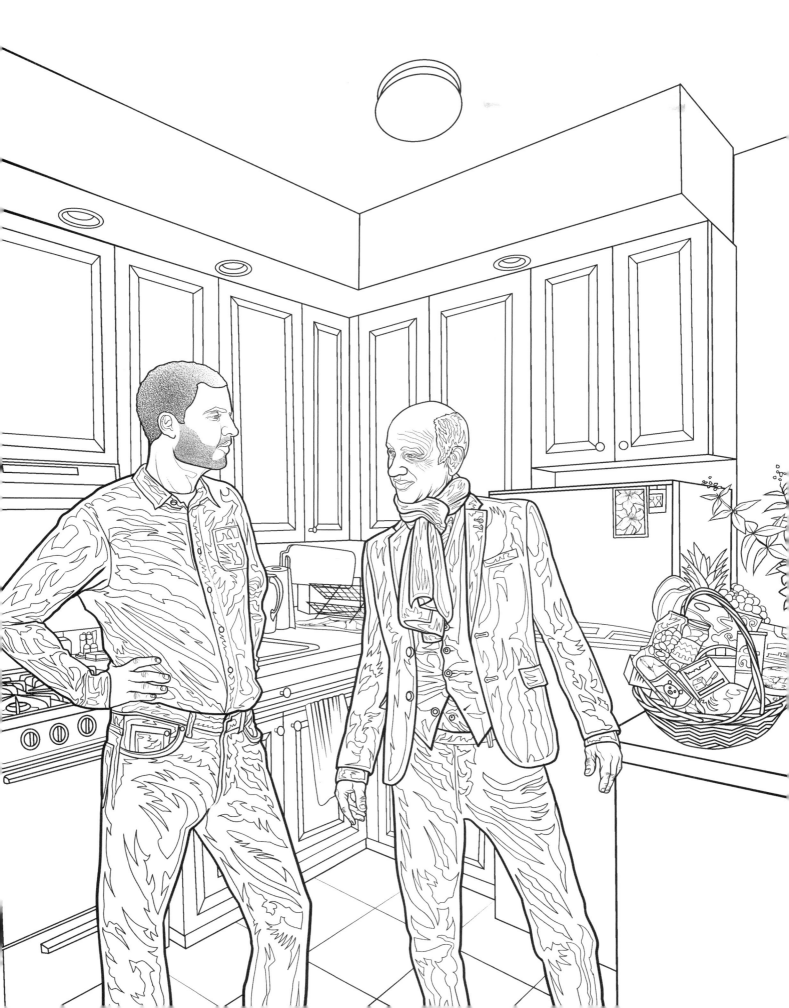

Las Vegas has become a child's picture book dream of a city — here a storybook castle, there a sphinx-flanked black pyramid beaming white light into the darkness as a landing beam for UFOs, and everywhere neon oracles and twisting screens predict happiness and good fortune, announce singers and comedians and magicians in residence or on their way, and the lights always flash and beckon and call. Once every hour a volcano erupts in light and flame. Once every hour a pirate ship sinks a man o' war.

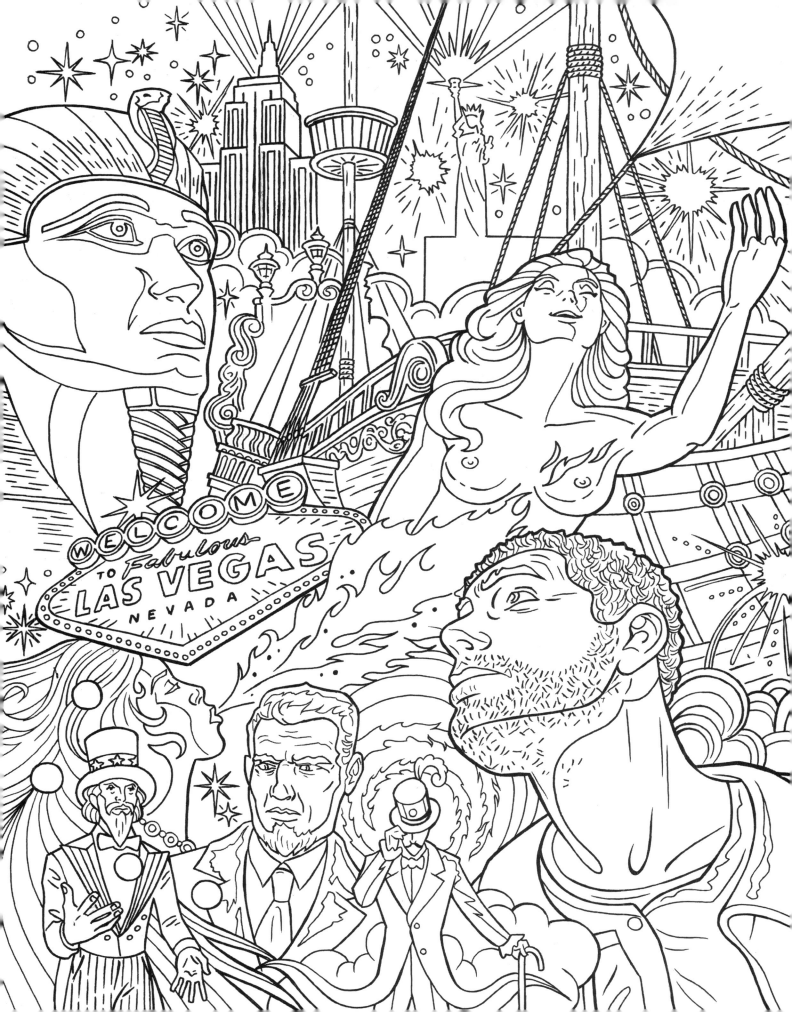

But it was a dream, and in dreams, sometimes, you have no choices: either there are no decisions to be made, or they were made for you long before ever the dream began. Shadow continued to climb, pulling himself up. His hands hurt. Bone popped and crushed and fragmented under his bare feet, cutting them painfully. The wind tugged at him, and he pressed himself to the spire, and he continued to climb the tower.

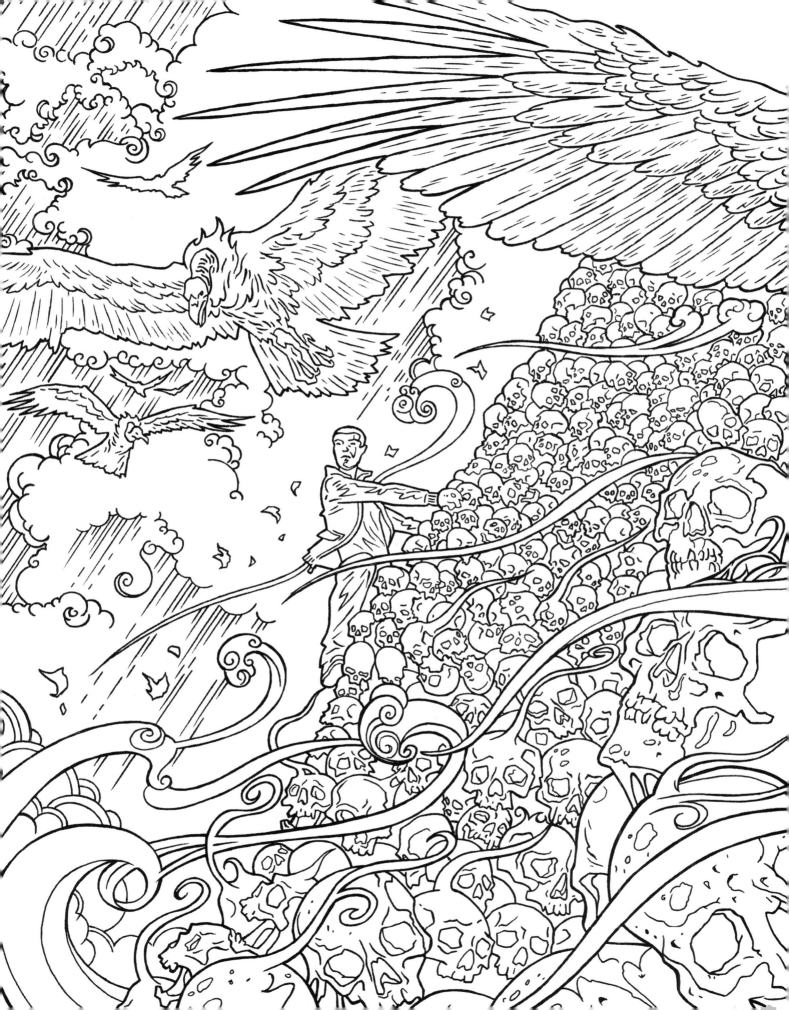

There was a girl, and her uncle sold her, *wrote Mr. Ibis in his perfect copperplate handwriting.*

That is the tale; the rest is detail.

There are stories that are true, in which each individual's tale is unique and tragic, and the worst of the tragedy is that we have heard it before, and we cannot allow ourselves to feel it too deeply. We build a shell around it like an oyster dealing with a painful particle of grit, coating it with smooth pearl layers in order to cope. This is how we walk and talk and function, day in, day out, immune to others' pain and loss. If it were to touch us it would cripple us or make saints of us; but, for the most part, it does not touch us. We cannot allow it to.

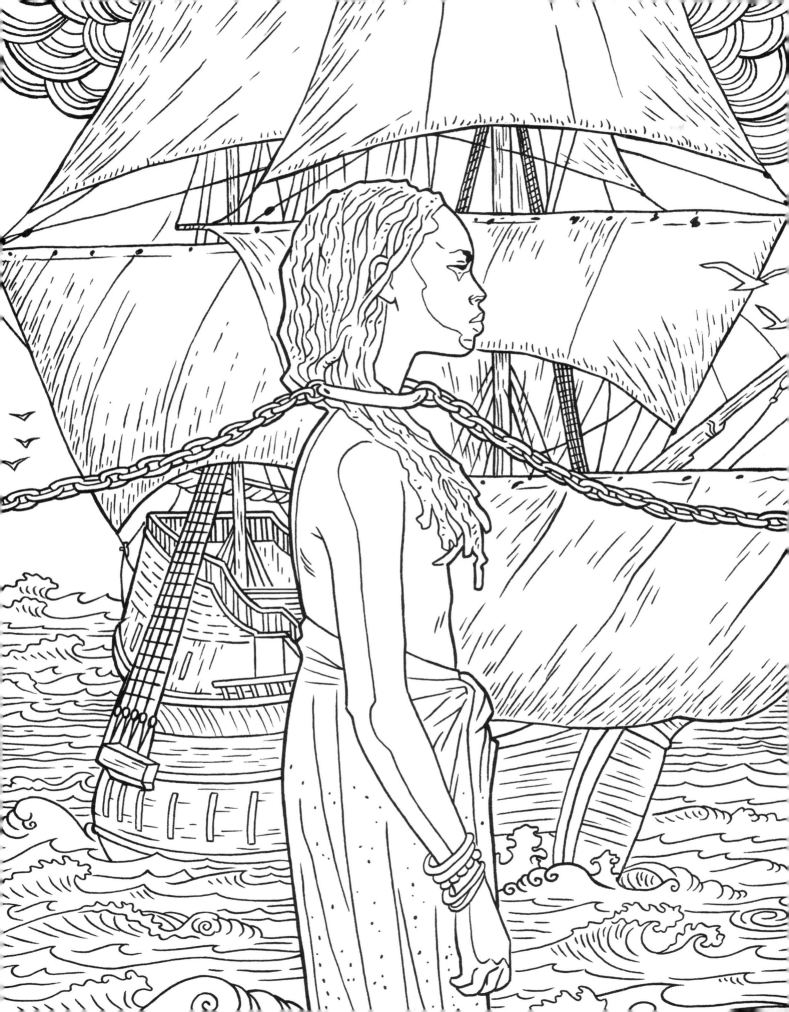

Shadow drove west, across Wisconsin and Minnesota and into North Dakota, where the snow-covered hills looked like huge sleeping buffalo, and he and Wednesday saw nothing but nothing and plenty of it for mile after mile. They went south, then, into South Dakota, heading for reservation country. . . .

As they passed their first signpost for Mount Rushmore, still several hundred miles away, Wednesday grunted. "Now that," he said, "is a holy place."

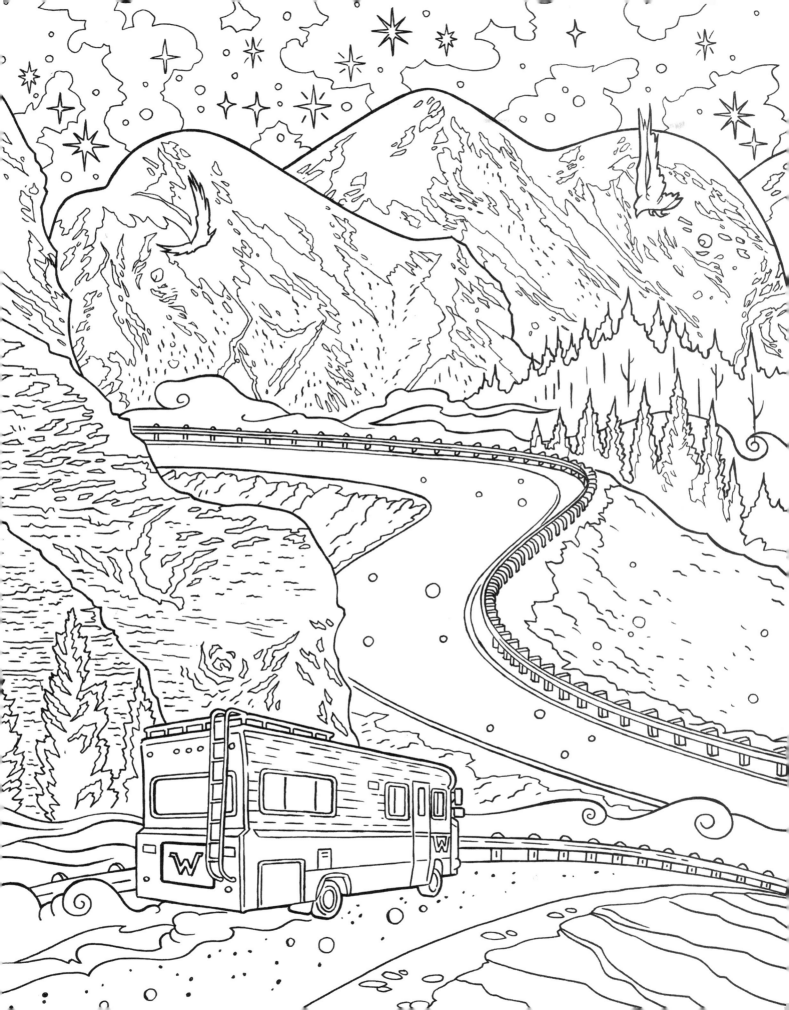

A woman's voice on the phone. "Yes?"

"This is Mister Town, for Mister World."

"Hold please. I'll see if he's available."

There is silence. Town crosses his legs, tugs his belt higher on his belly—*got* to lose these last ten pounds—and away from his bladder. Then an urbane voice says, "Hello, Mister Town."

"We lost them," says Town.

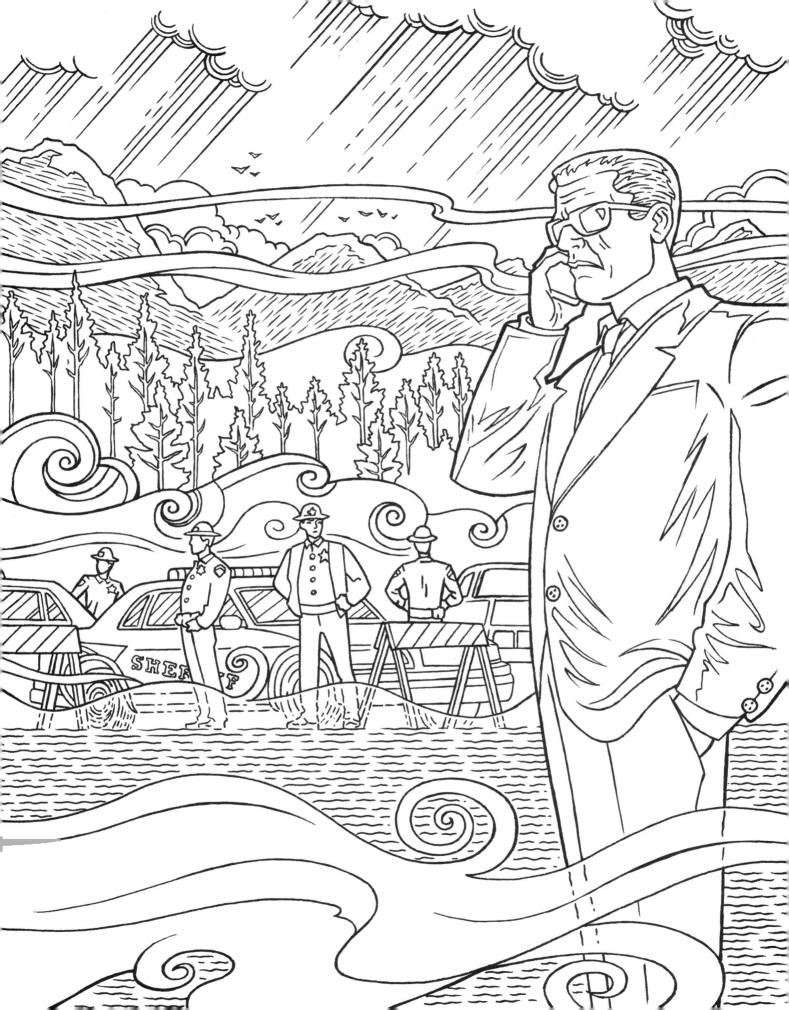

"When I touched that bone, I was in the mind of a guy named Town. He's with that spookshow. He hates us."

"Yes."

"He's got a boss named Mister World. He reminds me of someone, but I don't know who. I was looking into Town's head—or maybe I was in his head. I'm not certain."

"Do they know where we're headed?"

"I think they're calling off the hunt right now."

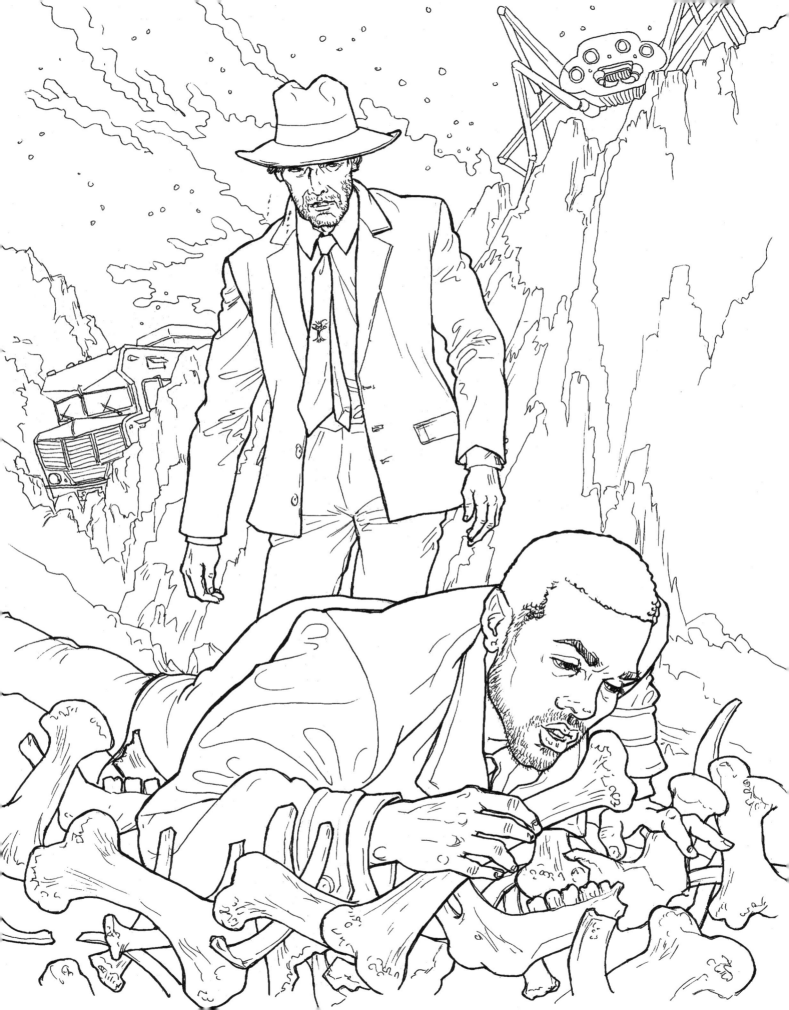

"I miss you," he admitted.

"I'm here," she said.

"That's when I miss you the most. When you're here. When you aren't here, when you're just a ghost from the past or a dream from another life, it's easier then."

She squeezed his fingers.

"So," he asked. "How's death?"

"Hard," she said. "It just keeps going."

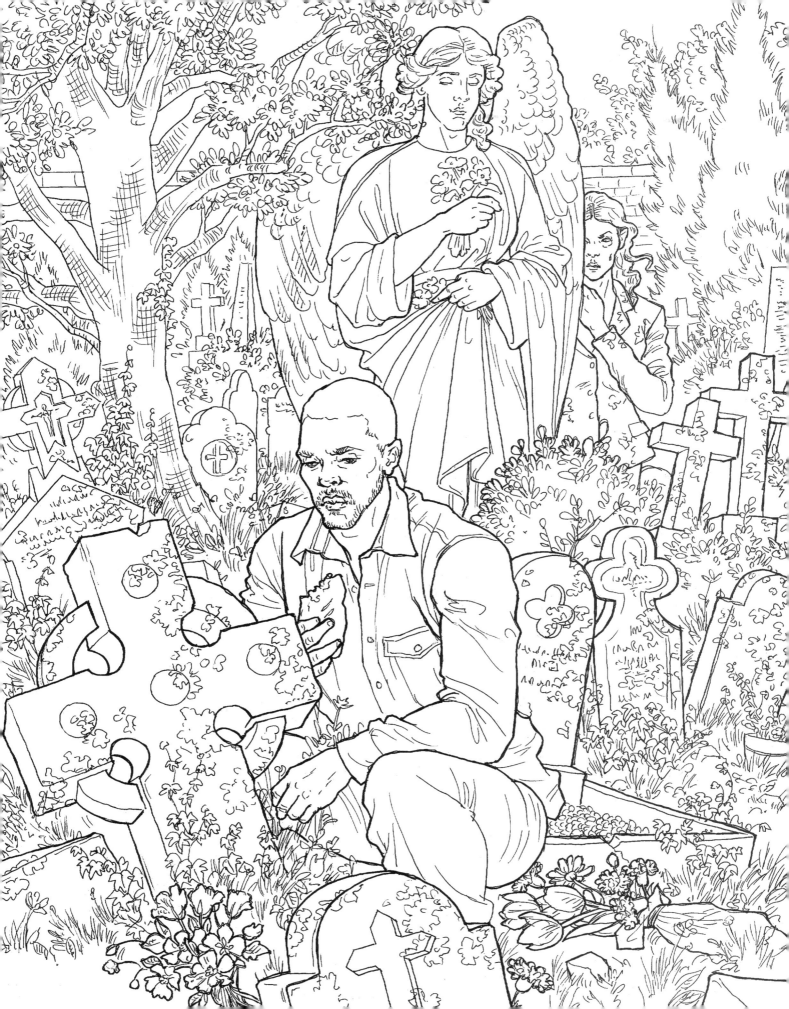

Headlights come up behind her, slowing as they approach her, and she turns her face to the street and smiles. The smile freezes when she sees the car is a white stretch limo. Men in stretch limos want to fuck in stretch limos, not in the privacy of Bilquis's shrine. Still, it might be an investment. Something for the future.

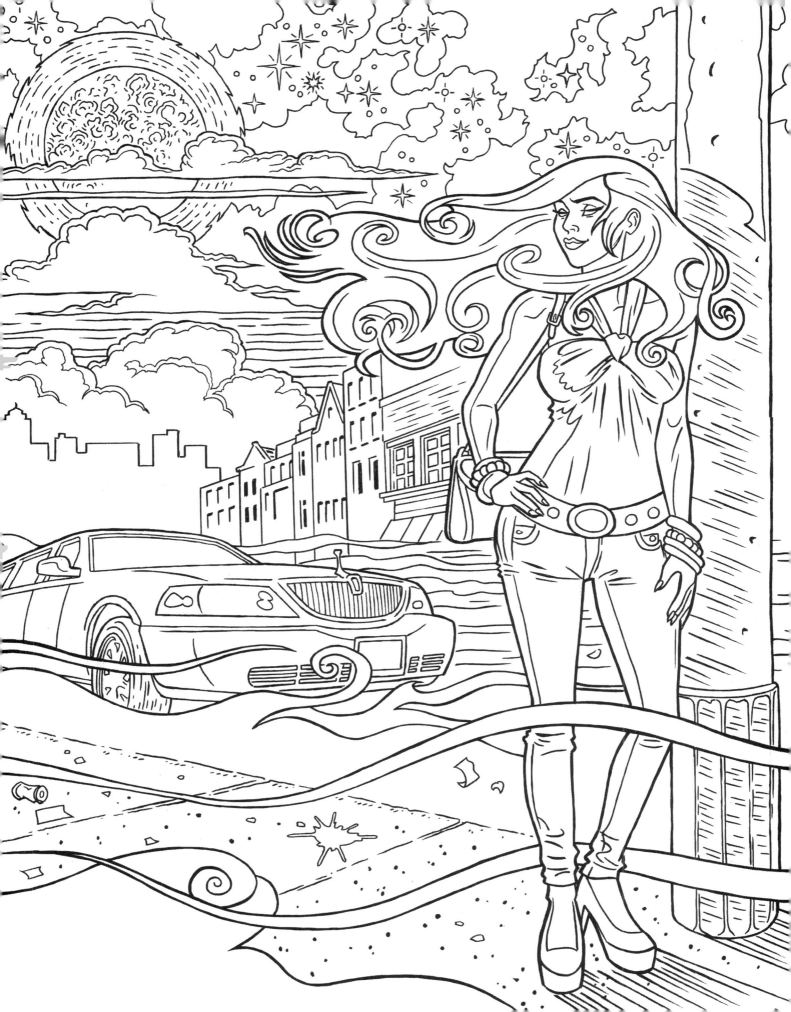

Wednesday said, "Organizing gods is like herding cats into straight lines. They don't take naturally to it." There was a deadness, and an exhaustion, in Wednesday's voice that Shadow had not heard before.

"What's wrong?"

"It's hard. It's too fucking hard. I don't know if this is going to work. We might as well cut our throats. Just cut our throats."

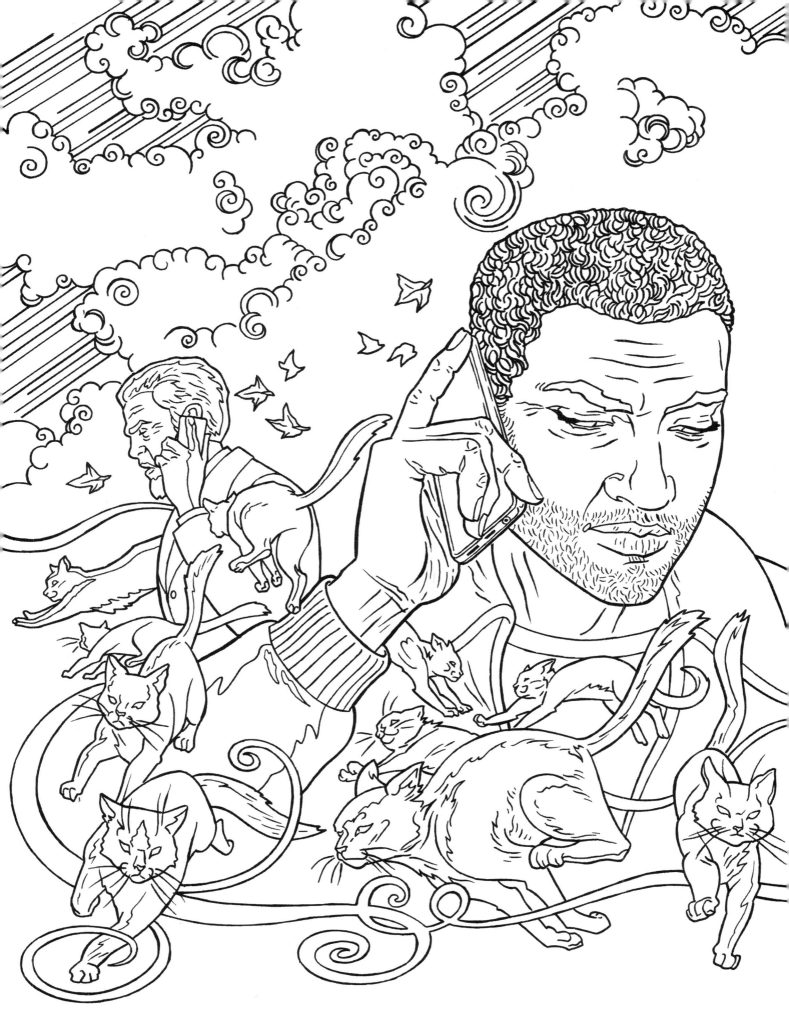

The screen flickered and went black. The words "LIVE FEED" pulsated in white at the bottom left of the screen. A subdued female voice said, in voiceover, "It's certainly not too late to change to the *winning* side. But you know, you *also* have the freedom to stay *just* where you are. That's what it means to *be* American. *That's* the miracle of America. Freedom to believe means the freedom to believe the wrong thing, after all. Just as freedom of *speech* gives you the right to stay silent."

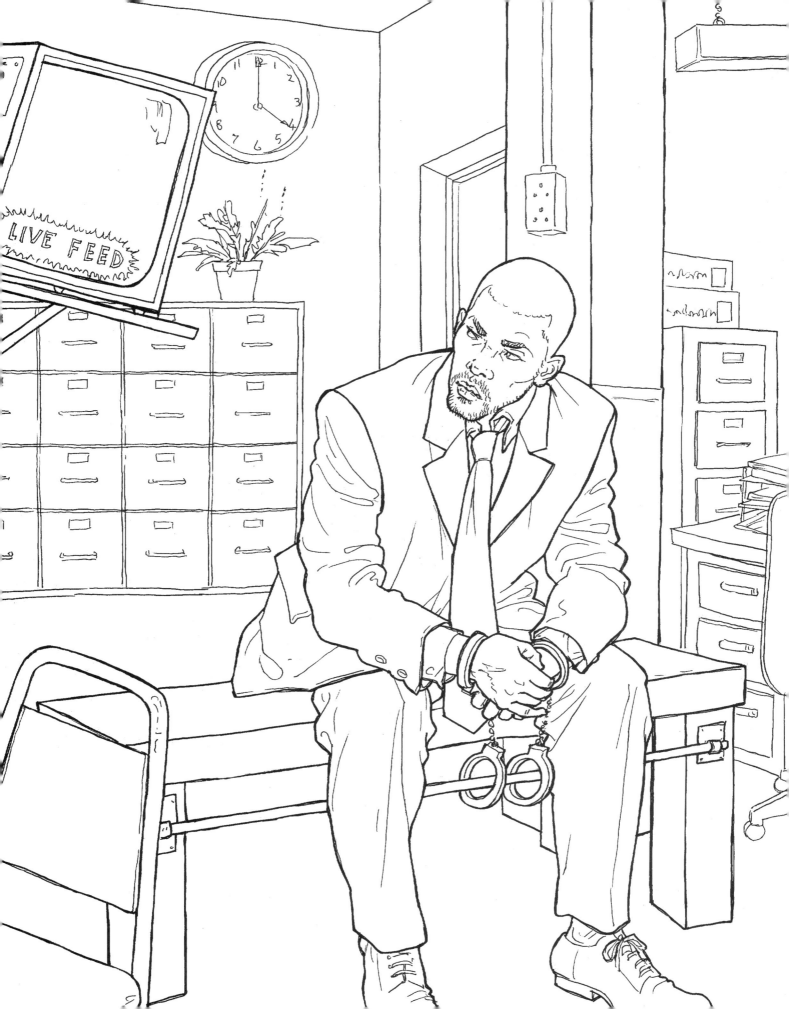

The words LIVE FEED became REPLAY. Slowly now the red laser pointer traced its bead onto Wednesday's glass eye, and once again the side of his face dissolved into a cloud of blood. Freeze frame.

"Yes, it's still God's Own Country," said the announcer, a news reporter pronouncing the final tag line.

"The only question is, which gods?"

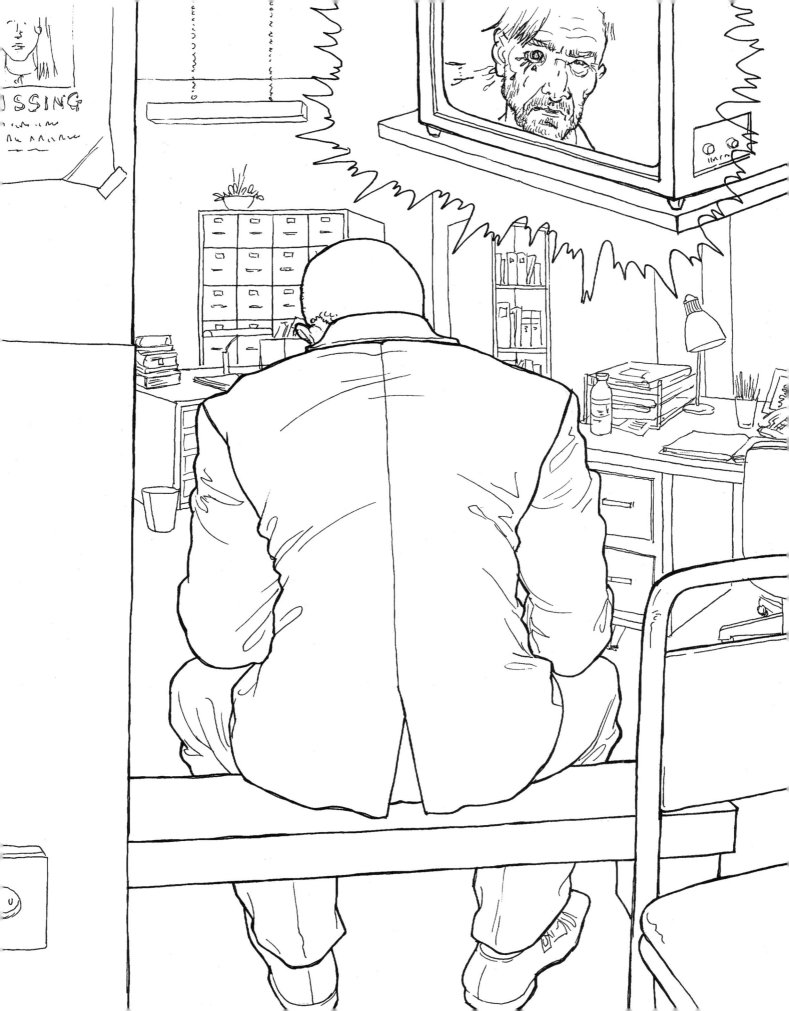

Determining the exact center of anything can be problematic at best. With living things—people, for example, or continents—the problem becomes one of intangibles: What is the center of a man? What is the center of a dream? And in the case of the continental United States, should one count Alaska when one attempts to find the center? Or Hawaii?

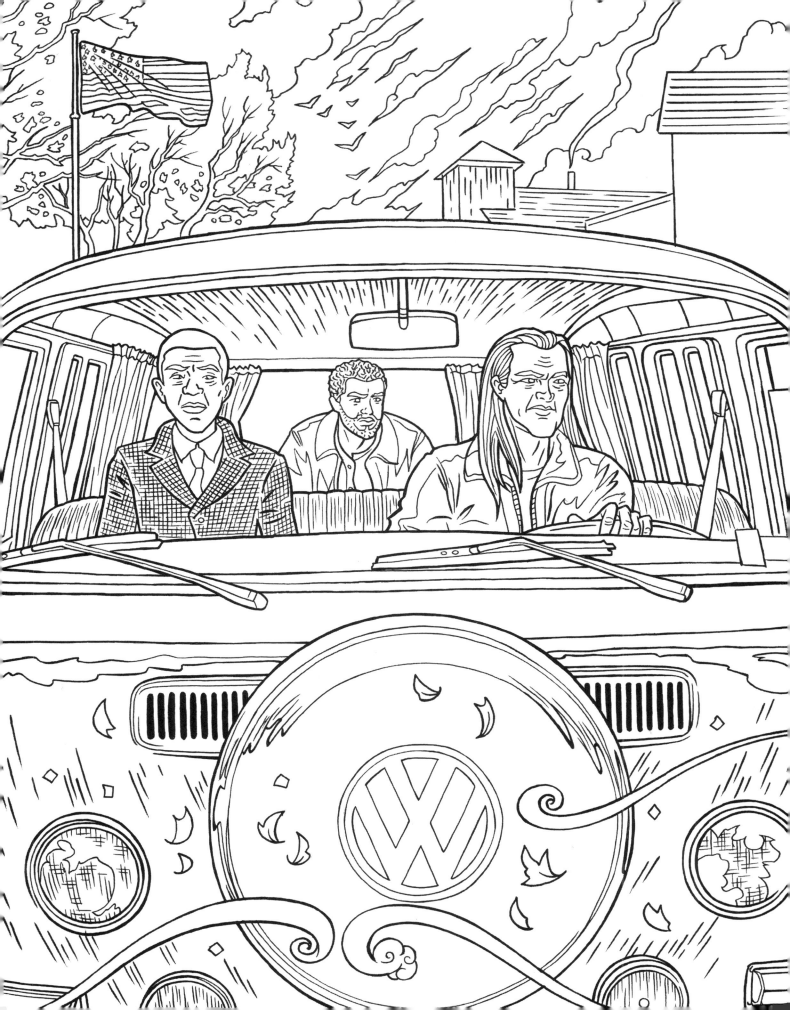

"Here," said Mr. Town, "Mister World wanted you to have this." It was a glass eye. There was a hairline crack down the middle of it, and a tiny chip gone from the front. "We found it in the Masonic hall, when we were cleaning up. Keep it for luck. God knows you'll need it."

Shadow closed his hand around the eye. He wished he could come back with something smart and sharp and clever, but Town was already back at the Humvee, and climbing up into the car; and Shadow still couldn't think of anything clever to say.

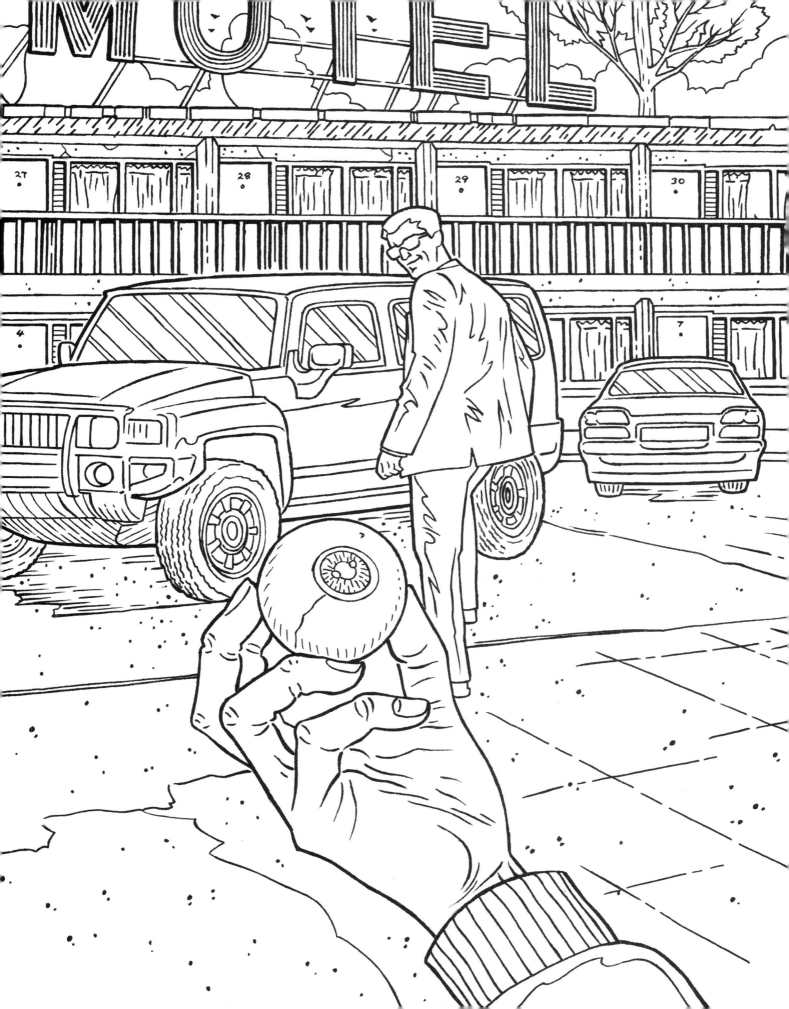

"All your questions can be answered, if that is what you want. But once you learn your answers, you can never unlearn them."

"Which path should I take?" he asked. "Which one is safe?"

"Take one, and you cannot take the other," she said. "But neither path is safe. Which way would you walk — the way of hard truths or the way of fine lies?"

"Truths," he said. "I've come too far for more lies."

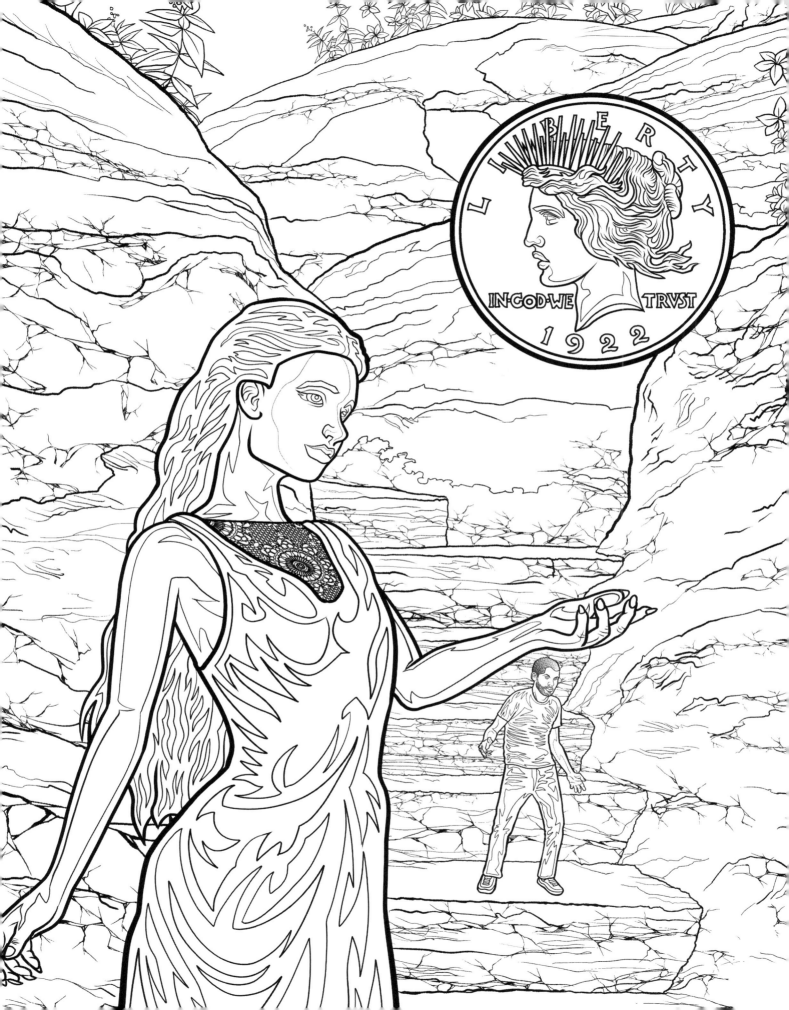

Inside the coin: LIBERTY · IN GOD WE TRVST · 1922

They came to Lookout Mountain from all across the United States. They were not tourists. They came by car and they came by plane and by bus and by railroad and on foot. Some of them flew—they flew low, and they flew only in the dark of the night, but still, they flew. Several of them traveled their own ways beneath the earth. Many of them hitchhiked, cadging rides from nervous motorists or from truck drivers. Those who had cars or trucks would see the ones who had not walking beside the roads or at rest stations and in diners on the way, and, recognizing them for what they were, would offer them rides.

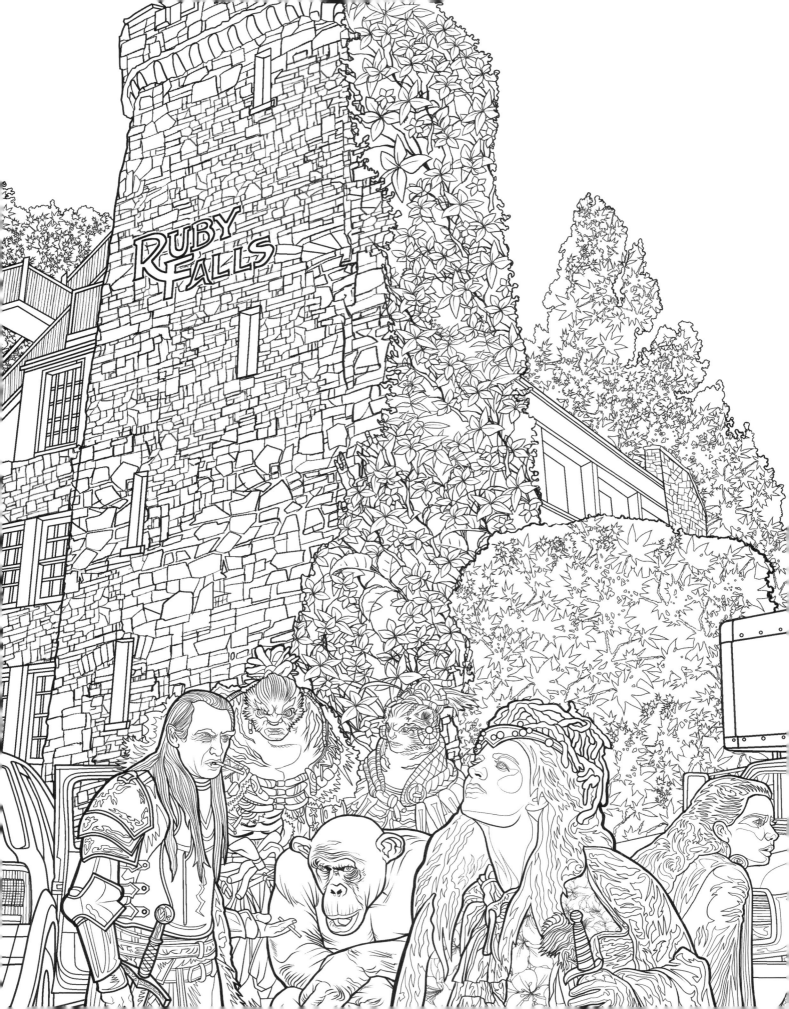

The tree was large; it seemed to exist on its own sense of scale. Tow could not have said if it was fifty feet high or two hundred. Its bark was the gray of a fine silk scarf.

There was a naked man tied to the trunk a little way above the ground by a webwork of ropes, and there was something wrapped in a sheet at the foot of the tree. . . .

Shadow hung, limply, from the ropes that tied him to the tree. Town wondered if the man were still alive; his chest did not rise or fall. Dead or almost dead, it did not matter.

"Hello, asshole," Town said, aloud. Shadow did not move.

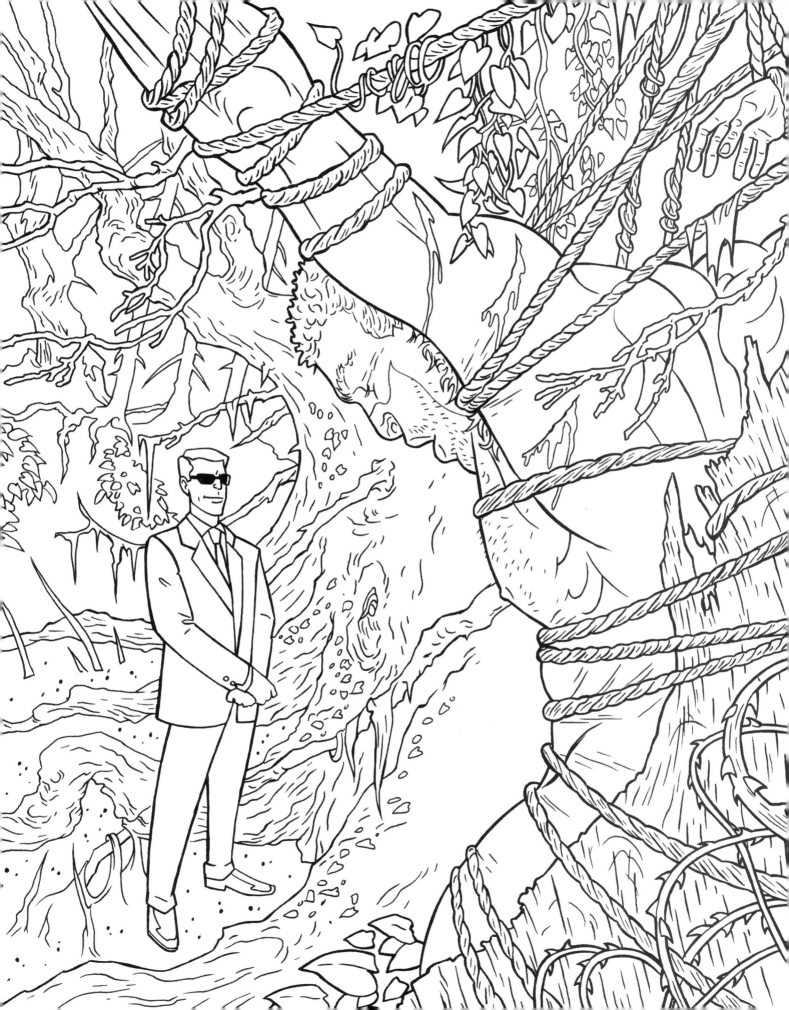

"This is a bad land for gods," said Shadow. . . . "Either you've been forgotten, or you're scared you're going to be rendered obsolete, or maybe you're just getting tired of existing on the whim of people." . . .

 Shadow shook his head. "You know," he said, "I think I would rather be a man than a god. We don't need anyone to believe in us. We just keep going anyhow. It's what we do."

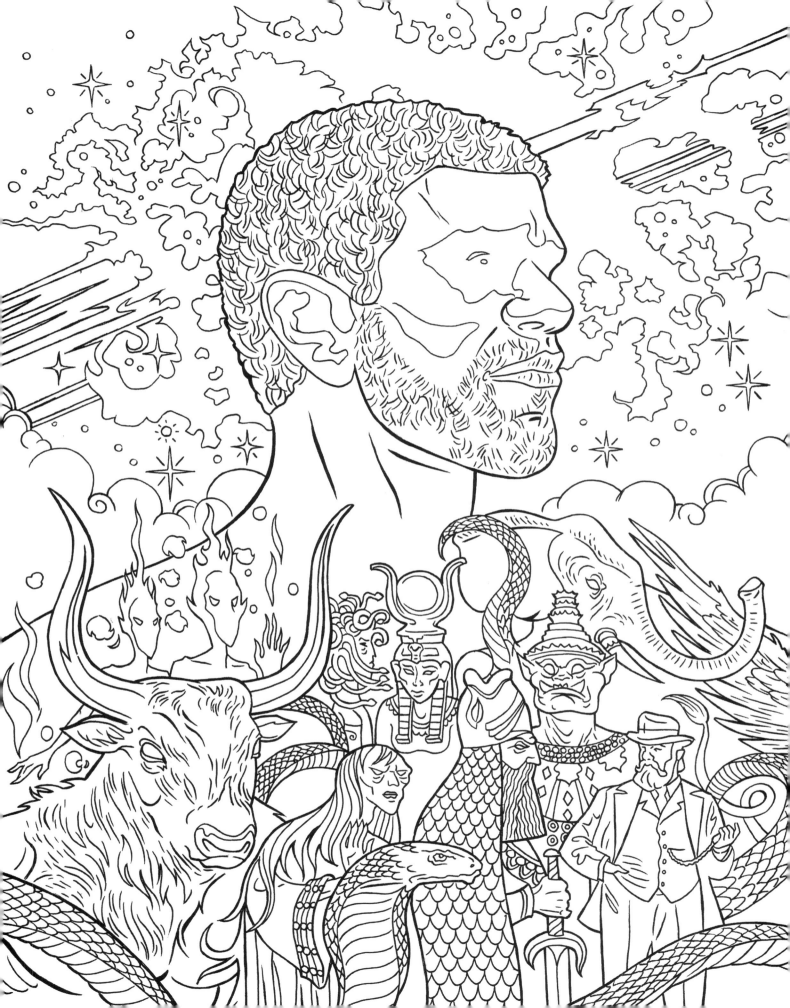

And then Shadow realized that the lights were going out. The gods were leaving that place, first in handfuls, and then by scores, and finally in their hundreds.

A spider the size of a rottweiler scuttled heavily toward him, on seven legs; its cluster of eyes glowed faintly. Shadow held his ground, although he felt slightly sick. When the spider got close enough, it said, in Mr. Nancy's voice, "That was a good job. Proud of you. You done good, kid."

"Thank you," said Shadow.

"We should get you back. Too long in this place is goin' to mess you up."

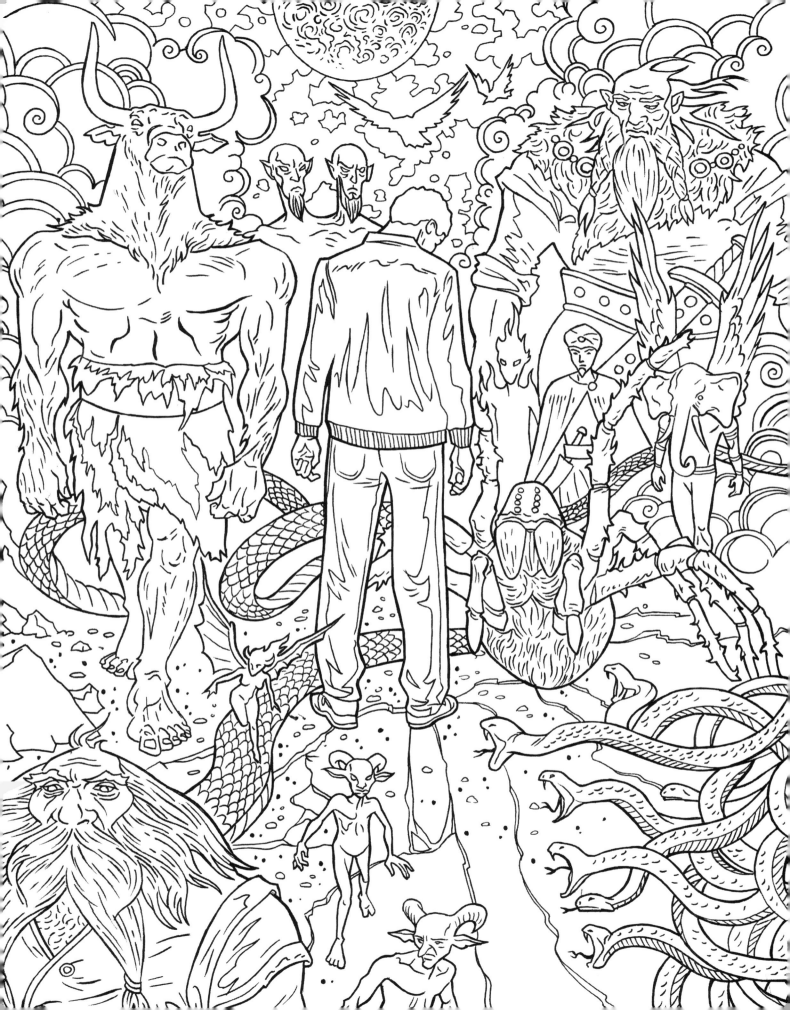

"I love you, babes," said Shadow.

"Love you, puppy," she whispered.

He closed his hand around the golden coin that hung around her neck. He tugged, hard, at the chain, which snapped easily. Then he took the gold coin between his finger and thumb, and blew on it, and opened his hand wide.

The coin was gone.

Her eyes were still open, but they did not move. He bent down then, and kissed her, gently, on her cold cheek, but she did not respond. He did not expect her to. Then he got up and walked out of the cavern, to stare into the night.

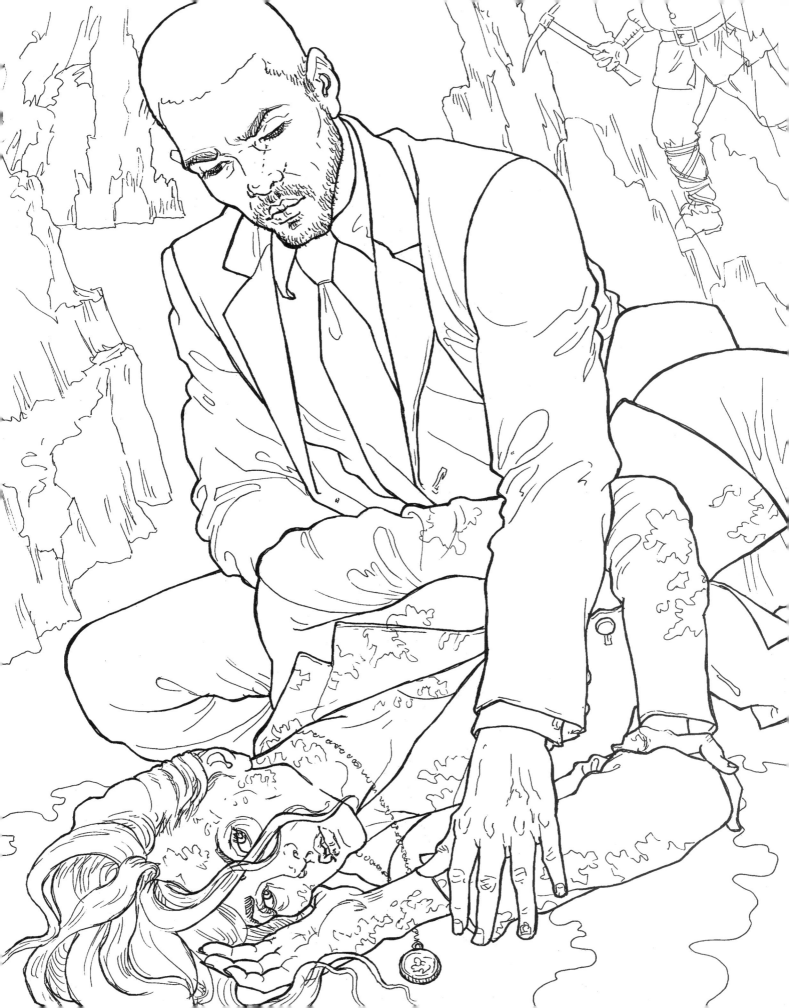

It's in the trunk, he thought.

The trunk was open an inch. He reached down and opened it the rest of the way, pulling it up.

The smell was bad, but it could have been much worse: the bottom of the trunk was filled with an inch or so of half-melted ice. There was a girl in the trunk. She wore a scarlet snowsuit, now stained, and her mousy hair was long and her mouth was closed, so Shadow could not see the blue rubber-band braces, but he knew that they were there. The cold had preserved her, kept her as fresh as if she had been in a freezer.

Her eyes were wide open, and she looked as if she had been crying when she died, and the tears that had frozen on her cheeks had still not melted. Her gloves were bright green.

"You were here all the time," said Shadow to Alison McGovern's corpse.

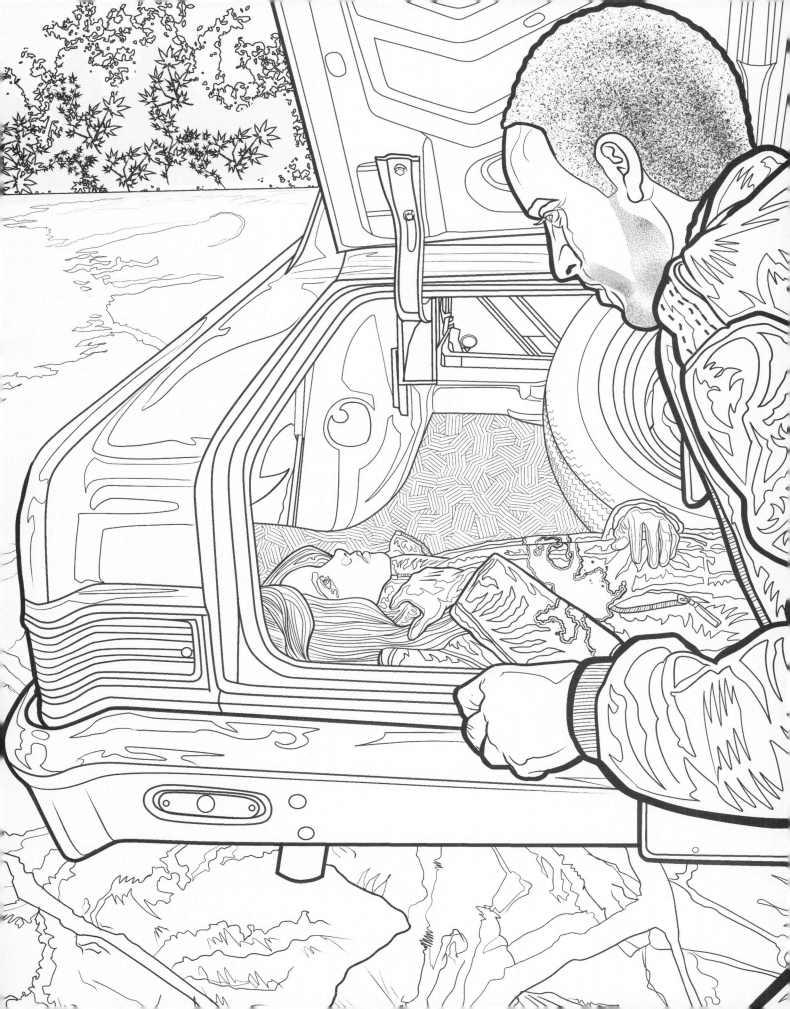

Postscript

"Hey," said Shadow. "I have something for you." His hand dipped into his pocket, and palmed the object he needed. "Hold your hand out," he said.

Odin looked at him strangely and seriously. Then he shrugged, and extended his right hand, palm down. Shadow reached over and turned it so the palm was upward.

He opened his own hands, showed them, one after the other, to be completely empty. Then he pushed the glass eye into the leathery palm of the old man's hand and left it there.

"How did you do that?"

"Magic," said Shadow, without smiling.

ABOUT THE AUTHOR

NEIL GAIMAN . . . is a poet, an artist, a songwriter, a screenwriter and film director, and a comics writer. First and foremost, however, he is an author of books for readers of all ages.

His adult books include the novels *Neverwhere, Stardust, American Gods, Anansi Boys, The Ocean at the End of the Lane,* and *Good Omens* (with Terry Pratchett); the Sandman series of graphic novels; and the short story collections *Smoke and Mirrors, Fragile Things,* and *Trigger Warning.* His novels for younger readers include *Coraline* and *The Graveyard Book,* which was awarded the Newbery Medal, the highest honor given in U.S. Children's literature, as well as the Locus Award for Best Young Adult Book and the Hugo Award for Best Novel. The awarding of the 2010 UK Carnegie Medal makes Gaiman the first author ever to win both the Newbery Medal and the Carnegie Medal with the same book.

ABOUT THE ARTISTS

YVONNE GILBERT is a British artist and book illustrator whose work runs the gamut from children's books and postage stamps to posters and record sleeves. Her love of fairy-tales and history has resulted in the design and illustration of many books for publishers around the world. Yvonne lives in Yorkshire, England.

CRAIG PHILLIPS is an award-winning illustrator who has worked for publishers and advertising agencies in the U.S., Australia, and Europe for more than a decade. In addition to creating cover and interior art for hundreds of books, he has designed tour posters for groups such as the Red Hot Chili Peppers and Foo Fighters, and his work has appeared in many publications, including *Rolling Stone* magazine.

JON PROCTOR began his career in the comic book industry, working at both Marvel Comics (the Electra and Daredevil series, the Gun Theory series) and DC Comics (Batman & Robin). His clients include the *Wall Street Journal, FHM* (London), Sundance Publishing, and *Heavy Metal* magazine. Jon received his degree from the College of Art and Design in Savannah, Georgia, where he lives.